MAKE YOUR OWN

TEMPORARY

TATTOO

MAKE YOUR OWN
T·E·M·P·O·R·A·R·Y
TATTOO

by Roy Zuckerman & Jean-Chris Miller

FROM TEMPTU®
the Originators of the Long-Lasting Temporary Tattoo

BLACK DOG
& LEVENTHAL
PUBLISHERS
NEW YORK

ISBN: 1-57912-080-6

Library of Congress Cataloging-in-Publication Data Available

Interior design: Paul Kepple

Cover design: Martin Ogolter

a book soup publishing book

The paints and transfers included in this kit contain only FDA-approved ingredients and are intended for cosmetic use only. Care should be taken to follow the directions carefully. If you have sensitive skin, be sure to test your skin for allergic reactions to the paints in this kit twenty-four hours before applying further paint. Authors and publisher accept no liability with regard to the use of the paints and techniques contained in this book.

Printed in the United States of America

Black Dog & Leventhal Publishers, Inc.
151 West 19th Street
New York, New York 10011

Distributed by
Workman Publishing Company
708 Broadway
New York, New York 10003

h g f e d c b a

TABLE OF CONTENTS

INTRODUCTION

AS LITTLE KIDS, EACH AND EVERY ONE OF US ENJOYED taking a pen or paints to our skin and decorating our bodies. We liked the different colors and patterns on our skin—it made us feel creative and in control of our own bodies.

This early form of self-expression grows and develops in many ways as we get older. We cut, color, and style our hair; use makeup to hide or to enhance; we grow, manicure, and paint our nails; we diet and work out in order to change the shape of our bodies. Some of us pierce our ears, nose, navels, or other body parts; some go to tanning salons to darken our skin and others indulge in a little plastic surgery, liposuction, or permanent makeup.

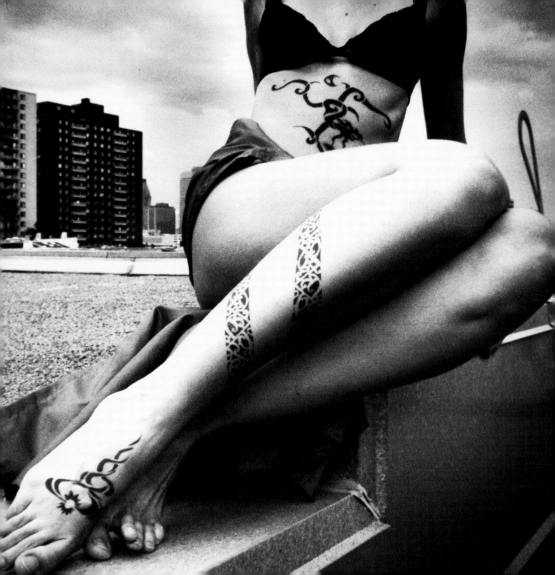

Changing our physical appearance to suit ourselves is nothing new; the need to decorate our bodies is as old as humanity itself. Throughout civilization there have been many different styles and methods used to alter our appearance and modify our bodies. The desire to paint, puncture and permanently modify ourselves is part of what makes us human beings. Hunters used body paint to camouflage themselves centuries ago just as hunters do today. Young girls today spend hours staining their faces and bodies with bright colors in order to be sexy and attractive just as the ancients did. Different kinds of body adornment have been used to dramatic effect since our beginning.

And one of the most dramatic ways to change our bodies is through tattooing: placing colored pigment in the skin by puncturing it with rapidly moving needles in order to make an everlasting image. Or, for the purposes of this book and kit, simply painting our bodies.

Why is tattooing so powerful? There are many reasons, but the main one is that it's a way to express yourself creatively, whether you have any artistic talent or not. If a picture is worth a thousand words, a beautiful tattoo is like having your deepest desires or beliefs laid out for the world to see. The artistic possibilities of tattooing these days are endless; anyone who wants to can own an amazing piece of art...and the best part of all is that the canvas is you!

There are other explanations as to why tattooing is so meaningful. For one thing, it's permanent; whatever design you choose will be with you for the rest of your life. ("But what about laser surgery?" you say. Lasering off tattoos is a long process, very expensive

and painful, and only works on certain tattoos—but more on that later.) Secondly, there is some amount of pain and blood in the process. How much pain and bleeding is experienced varies from person to person; it also depends on where you get your tattoo. The pain is part of the process, like any other "rite of passage" you must suffer through this ritual to earn the right to wear your body art. Like the saying goes, "If it didn't hurt, everybody would have one."

Finally, your tattoo is full of all the meaning and magic you give it; it can be symbolic of a person, a place, an event, a belief—anything you like. And by getting a tattoo you're participating in an expressive ritual that people all over the world, since the beginning of recorded time (at the very least) have also participated in. A tattoo ties your past, present and future together. It is a tangible link between body and soul. (Now don't you feel silly for thinking the only reason to get one is because "it looks cool?")

HOW TATTOOS CAME TO BE

EXCAVATIONS OF PREHISTORIC CAVES DATING BACK TO THE Paleolithic era (more than 10,000 years ago) have uncovered small bowls which had been filled with colored pigment lying next to bones and sticks that were filed to sharp points; archeologists speculate that these may have been tools for tattooing. From this earliest instance, a recorded account of tattooing spread forth to all cultures throughout history.

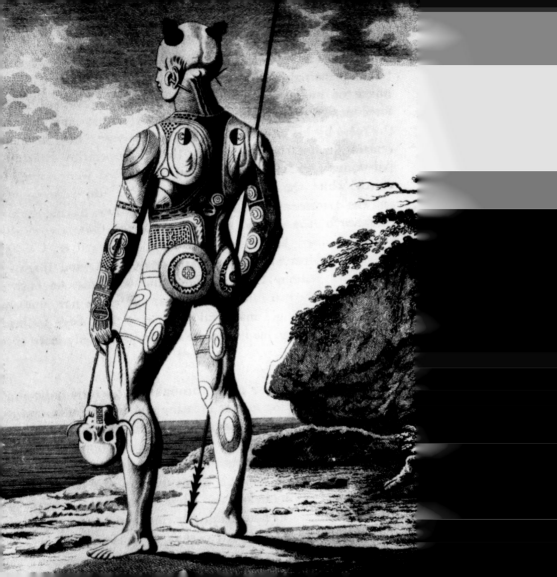

Darwin wrote that, "No one great country can be named, from the polar regions in the north to New Zealand in the south, in which the aborigines do not tattoo themselves." No other species on this planet has the need to decorate itself like we do. It's fair to say that the urge to mark our bodies is as much a part of our Homosapien makeup as is the urge to explore and explain our surroundings, to cultivate and to build on the land, to communicate and record our thoughts, to take part in rituals and rites, to think, dream, and do. Whether it's temporary or permanent—we were born to adorn!

HOW TEMPORARY TATTOOS CAME TO BE

IF WE DEFINE A "REAL" TATTOO AS AN IMAGE PERMANENTLY marked on the skin, other body graphics which fade or can be removed can be categorized as "temporary tattoos."

In the early twentieth century, temporary tattoos were strictly perceived as "kid stuff." Real men would never consider a temporary tattoo. In the 1930s, "lick and stick tattoos" or "cockamamies," became a popular novelty item, and were even included as one of the prizes found in a box of Crackerjacks. They were printed on paper with water-soluble food dyes, often in outline form only, and would easily wash off or fade.

In the 1960s, several American companies modified decals that were used to decorate teacups and other items to create a more long-lasting, stick-on tattoo. In this process, the

image was printed on a piece of thin plastic on a coating-backed paper. When water was applied and the tattoo image was pressed against the skin, the printed plastic slid onto the skin and adhered. Today, "water-slide" decals, as they are called, are a popular retail and promotional item. However, while they are realistic and durable, these decals often shine and collect dirt and dust after a day or two.

THE ROAD TO TEMPTU

TEMPTU COSMETIC TATTOOS ARE THE LATEST VERSION OF TEMPORARY tattoos, invented by Dr. Samuel Zuckerman for the motion picture called (not coincidentally) *Tattoo*, starring Bruce Dern and Maude Adams in 1981. Dr. Zuckerman, a world-famous cosmetic chemist and inventor, was approached by Fred Blau and Mike Hancock, the makeup artists who had applied the tattoos on Rod Steiger in the film *The Illustrated Man* several years earlier. The makeup men wanted to avoid the grueling five-hour daily makeup applications needed to decorate the star's body, and they needed makeup which would last for several days, would not shine, and would hold up under the hot lights and torrid love scenes of *Tattoo*.

After several months of testing, the new body paint was born—although for the film, outlines were transferred from a piece of acetate wet onto the skin, not from the paper included in this kit.

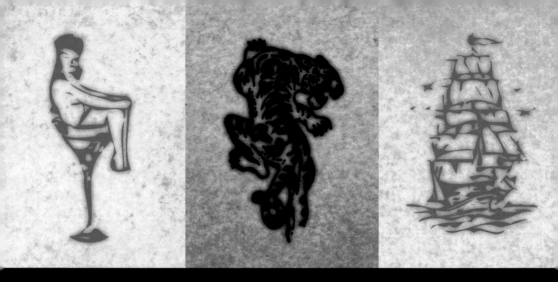

Traditional tattoos adapted by Temptu for the Broadway musical **Miss Saigon.**

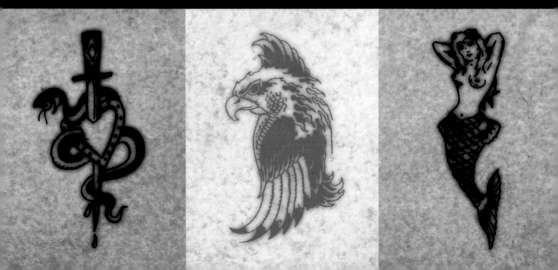

After the film's release, Dr. Zuckerman's son Roy founded Temptu Marketing, Inc. and completed the development of their unique outline transfer process.

This form of temporary tattoo has become the industry standard for rock videos, movies, theatre, fashion, theme parks, and fairs. Temptus are featured in such films as *Cape Fear*, *Dead Man Walking*, *Practical Magic*, *Die Hard*, and others, as well as on Broadway in *Cabaret*, *Miss Saigon*, *Rent*, and other shows. Temptu has also created custom tattoos and "faux henna" for such designers as Anna Sui, Comme des Garçons, John Galliano, and Jean-Paul Gaultier. Temptu's work can be seen regularly on "Saturday Night Live," MTV, the World Wrestling Federation, and in countless videos. Temptu henna "tattoos" were also featured in ongoing episodes of "Xena: Warrior Princess."

Your Temptu tattoo kit is a great way to decorate yourself in a cool and original way. It allows you to experiment before committing to the real thing. You can try out designs on different parts of your body without waking up the next morning wondering what you've done to yourself (known as "the tattoo hangover"). The kit gives you the chance to have fun applying and wearing different designs while you learn what works and doesn't work for you. There's even an exclusive mail-in offer you can use to create your own Temptu transfers. And the look on your mother's face when she sees your new (Temptu) tattoo? Priceless. But watch out—she'll probably want one too.

Even tattoo artists now use the Temptu process for clients who wish to first "test drive" a tattoo. As one tattooist said early on, "They ain't real, but they ain't bad."

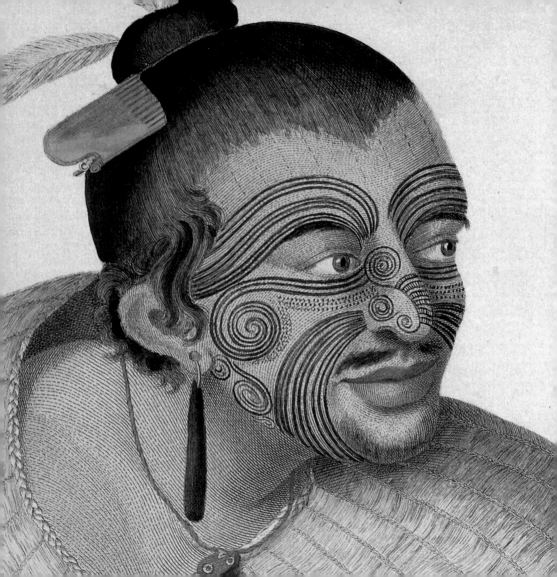

WHY · WE TATTOO

SO WHY DO WE DECORATE OUR BODIES? THE MOTIVATIONS to tattoo ourselves are as varied as the world we live in and all the people in it. Here are some of the cultural reasons for tattooing throughout the ages, just as relevant today as they were thousands of years ago.

TATTOOING FOR RELIGION/SPIRITUALITY

WHEN HERNANDO CORTÉS ENCOUNTERED THE AZTECS OF central Mexico in the sixteenth century, his scribes noted that they were covered in zemis, tattooed pictures of the many gods who helped them

through their daily lives. The zemi tattoos were immediately condemned as the work of the devil, since the only frame of reference the Spaniards had of tattoos were those found on criminals or heretics.

Contrary to the Conquistadors' opinion of tattoos, the tradition of showing devotion through skin art is at least as old as ancient Egypt (where some of the first designs were apparently representative of the gods they worshipped) and has been documented in various cultures throughout history.

A perfect example of a religious tattoo is the Jerusalem Cross, which dates back to the Crusades. After the Crusaders captured Jerusalem from the Moslems in 1099, they used the religious symbol on their war banners as a design for a tattoo. For centuries it became a memento for Christians making the pilgrimage to the Holy Land. Nowadays virtually any deity, from Jesus Christ to Kali to Buddha, is commonly used as a tattoo design.

TATTOOING FOR MAGIC/PROTECTION/HEALING

WHETHER IT'S THE TWENTY-FIRST CENTURY GIRL WHO GETS AN angel tattooed on her shoulder blade in order to "watch her back," or a twentieth-century rigger having "Hold Fast" tattooed on his hands so he doesn't fall from the mast of a tall ship, or a nineteenth-century fisherman getting a dolphin tattoo (traditional pro-

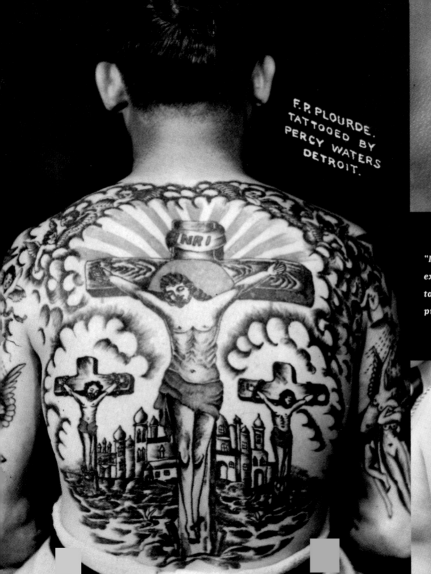

F.P. PLOURDE.
TATTOOED BY
PERCY WATERS
DETROIT.

"Inspirational"
examples of religious
tattoos—past and
present.

tection from sharks in his society), people have always believed in the magic of tattoos.

Many Native American tribes used animal tattoos for protection or fortification. They believed that when you received the tattoo of your animal totem, you also received the animal's characteristics. Even today, people will get an animal that they relate to tattooed on themselves.

Tattoos also have a long, abundant history as healing talismans, and many cultures used tattooing as medicine, usually inking the afflicted area to alleviate pain. Therapeutic tattooing can still be found among the peoples of Tibet, Samoa, the Arctic, and the Middle East.

TATTOOING FOR IDENTIFICATION

TATTOOING AS A FORM OF IDENTIFICATION HAS ALWAYS BEEN practiced, and is still around today. Early ID tattoos were used to show that you belonged to a specific clan, or that you were of noble birth, or maybe it even branded you as an outcast or an untouchable in your community. In any case, during the early years of Christianity, when it was still a banned religion, fellow worshippers knew each other by a small tattoo of a fish, a cross, or other Christian symbols which were easily identified by fellow worshippers but hidden from the rest of the world.

In the late days of the Roman Empire, soldiers were tattooed to keep them from deserting. By the 1800s, military tattooing had lost its air of stigma and was encour-

aged by many officers because it not only instilled a spirit of unity among soldiers but could also be used as a way of identification on the battlefield. This tradition carries on to this day.

Tattooing of prisoners and slaves for ID purposes dates back for centuries. In 413 BC 7,000 invading Athenians invaded Syracuse—and lost. As punishment, every Athenian's forehead was tattooed with a horse (which was the Syracusians' symbol). The Athenians were then sold as slaves. In 330 BC, Emperor Constantine banned tattooing the faces of slaves and prisoners, because he believed the face was a reflection of "divine beauty." This was not the end of penal tattooing, however. During World War II, millions of Jews, Communists, and homosexuals held in Nazi concentration camps were tattooed with a number.

Tattoos also served as a mystical passport to the next world. Celtic people believed members of the same clan all needed the same tattoo in order to find each other in the afterlife. The tattooed lines on a Maori's face told that person's life story—a story by which they would be judged when they died. And people in Borneo believed their tattoos not only helped them land favored positions in the afterworld, but that the tattoos actually lit the way for the dead. Today we're seeing tattoos used for very practical purposes, such as identifying lost pets or as "in the flesh" medical bracelets, with important health info tattooed on individual's bodies.

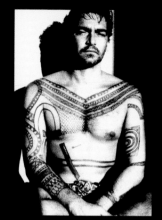

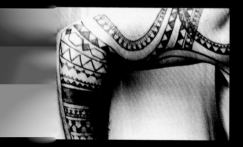

reproductions of French Polynesian tattoos—
amples of tattooing as a rite of passage.

TATTOOING AS A RITE OF PASSAGE

A RITE OF PASSAGE IS A CEREMONY THAT MARKS AN IMPORTANT stage in a person's life, like the transition from adolescence to adulthood, from single life to married life, from wife to mother. Tattooing has played a significant part in many culture's rite of passage rituals. In the days before sterilization methods were established, it was so painful and occasionally life-threatening that surviving the tattoo ritual proved your worth to your tribe as brave or blessed. Due to centuries of conquest, enslavement, and destruction of native civilizations, many of the old rituals and symbolism for this kind of tattooing have been lost. The invading cultures inevitably considered the native culture's tattooing traditions to be evil or primitive and did everything within their power to eradicate the practice.

The Drung women of China practice a tattoo tradition to this day that is an interesting twist on rite of passage ink-work. Upon reaching puberty, girls get facial tattoos which range from full facial ink to a few simple lines along the lower jaw—the extent varies from village to village. The tradition started during the Ming Dynasty (1368-1644), when the Drung were captured and turned into slaves by other invading groups. To prevent themselves from being raped, the women of the Drung tribe tattooed their faces to make themselves unattractive to their captors. Even though they no longer live under the threat of invasion, the women still use the custom as a symbol of adulthood.

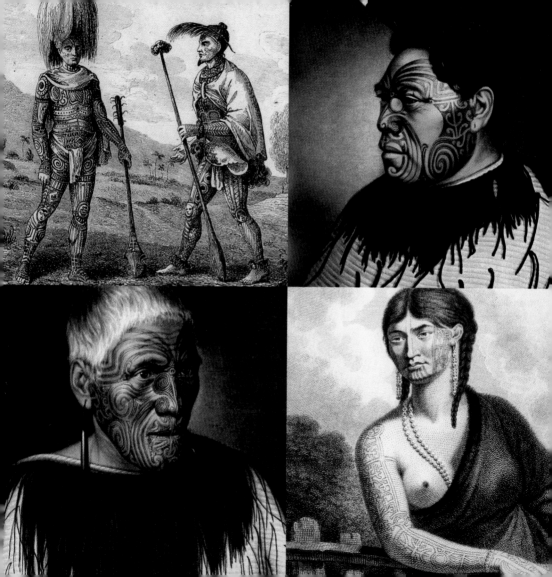

*Native cultures
around the world
used tattoos for a
variety of purposes.
They were symbols
of beauty, strength,
rites of passage,
and wisdom.*

TATTOOING FOR
BEAUTY/ATTRACTIVENESS

ONE OF THE GREAT LESSONS TO BE LEARNED IN STUDYING BODY ART from other cultures is that there are many ideas of what is considered "beautiful" in this world. Elongated necks, teeth filed to sharp points, stretched earlobes, a tusk through the nose—beauty is definitely in the eye of the beholder. In many Pacific Island cultures, women tattoo around or on their mouths to draw attention to their lips, a tradition that has been passed down for generations. In modern Western tattooing, permanent makeup is the most common form of beautification tattooing. Women (and men) have eyeliner tattooed around their eyes, add an attractive beauty mark, or even shade their lips and cheeks a permanent rosy pink. Cosmetic tattooing is also used to correct loss of pigment in the skin, to lessen the appearance of a scar, or to replace the lack of a feature. People who have scars that are difficult to hide also use tattooing; an ugly scar can be covered with a beautiful tattoo. The proper placement of a tattoo can make your shoulders look broader or your waist look smaller. It can enhance your body by tricking the eye.

TATTOOING AS A MEMENTO MORI

A LATIN PHRASE MEANING "REMEMBER THAT YOU MUST DIE," a *memento mori* is an object a person keeps to remind them of their own mortality. People from many different cultures tattoo themselves with skulls and skeletons to remind them of the inevitable—and to show that they are not afraid. Another kind of *memento mori*, especially popular in Western culture, is a tattoo done in memory of a dead person, such as a deceased parent or a slain friend. Other cultures also make marks for the dead. There is a custom among the indigenous people of Hawaii to tattoo their tongues during the mourning period of a lost loved one.

TATTOOS—PERMANENT AND TEMPORARY—TODAY

TATTOOING HAS HAD ITS UPS AND DOWNS AS FAR AS POPULARITY and acceptance go. The perception that tattoos are for criminals or sideshow freaks has roots in the fact that in the past, tattoos were used to brand criminals or to mark a person in a way that excluded them from "normal" society.

It's hard to change thousands of years of perception, but in the last twenty to thirty years, tattoos have become a popular and acceptable form of self-expression. In the

1960s Janis Joplin set a pop trend by showing off her tattoo on the cover of her album *Pearl*, and other rock and roll musicians followed suit. By the early 1980s, punk bands, rockabilly bands, and heavy metal bands all sported a heavily tattooed look, which was seen in magazines, on records, and TV, and had a lot to do with setting the current tattoo trend in motion.

Soon tattoos were not only seen on all kinds of "respectable" people, they were used in advertising to sell products, in fashion as clothing designs, and hung in museums as fine art. Of course, it is precisely the tattoo's stigma as being rebellious that makes it appealing to many people. There's no quicker way to set yourself apart than by permanently marking your body. It's a way of saying, "I'm not just another face in the crowd, I'm an individual—see!"

Now that tattooing has gained mainstream acceptance, it's easy to argue that it has become just another trend. But when you realize that it has been around forever, it becomes much more meaningful. To mark your skin in a way that's pleasing to you is to claim ownership of your body through self-expression. Just as some people customize their cars, bikes, rooms, and clothes—anything that they own—so, too, do some people customize their bodies. It's a way to be creative with the one thing you truly own in this life, your body.

THE TATTOOED TIMELINE

5000 BC

In Japan, clay figures with painted and carved faces suggestive of tattooing were found in burial tombs dating back to 500 bc. The figures had a spiritual purpose: they accompanied and protected the person they were buried with on the journey from this world to the next. The Ainu, an ancient people who first inhabited the island of Japan, were highly skilled and creative tattooists.

3300 BC

In 1991, the body of a man who had been buried in a glacier in the Italian

Alps near Austria for 5,300 years was uncovered. He had many tattoos on his body. Although we can't know for sure the reasons for his markings, because of other items found with him, it's speculated the tattoos were magical talismans which either protected him on his journey or were used to heal injuries or alleviate pain.

2160 BC

In 1891, a female mummy, identified as Amunet, one of the temple priestesses of the goddess Hathor, was discovered during an excavation. She had a number of tattooed markings on her arms, thighs, and belly. Because Amunet was a priestess of the goddess Hathor, who

was worshipped as the mother of all life on earth, archeologists believe that her tattoos represent fertility and sexual attractiveness.

1580 BC

Paintings and statues that date from Egypt during this time show people adorned with words and images on their bodies that may well be tattoos.

1300 BC

Mummies found in Libya from this period have tattoos that represent their gods and goddesses. Some markings represent a goddess who protected warriors, others refer to the sun god, and the oldest are images associated with the ancient god of revelry.

386 BC

Greek philosopher and teacher Plato suggests that people guilty of sacrilege should be tattooed and banished from the community.

37 AD

Roman Emperor Caligula amuses himself by, among other things, turning his senator's wives into prostitutes and having members of his royal court tattooed.

1000 BC

 Tools for tattooing have been found in Polynesian sites dating from this time. Although it's speculated that the tradition of Polynesian tattooing is much older, the tools were the first evidence of it. Tools similar to those found at this excavation are still used by traditional tattooists in Samoa today.

400 BC

A tribe which dates from the Iron Age, called the Pazyryks, left behind two great examples of tattooed ancients in the form of well-preserved mummies, one male and one female. They were discovered by Russian anthropologist Sergei Rudenko, who described the man's skin designs as animals, some easily recognizable, like a donkey, a deer, and a goat. Others seemed to be mythical creatures. The mummy of the woman was etched with fantastical beasts similar to those of the man.

787 AD

Calling it a barbaric practice, in this context meaning one associated with pagans or non-Catholics, Pope Hadrian bans tattooing throughout the Catholic world.

1066 AD

The tattoo-hating Normans virtually wipe out the ancient tradition in Britain (practiced by the Iberians, their descendants, and all previous invading tribes) when William the Conqueror leads the Norman invasion. Defending his homeland, the Anglo-Saxon king, Harold II, is killed during battle and is identified by his tattoos.

1566 AD

A Dutch sea captain lands on the coast of Newfoundland, where he encounters tattooed Eskimos. Probably realizing he can make money off of these unusual-looking "natives," he captures two of them (a young woman and a small child), brings them back to Holland, and puts them on exhibition.

1585 AD

John White, a British artist and explorer who sailed with Sir Walter Raleigh on one of his expeditions to America, makes numerous drawings of the tattooed natives they encounter. A few years later, Captain John Smith, who was captured by Pocahontas's father Powhatan,

would write about the different tattooed peoples he encountered in the New World.

Captain John Smith

1828 AD

Sailor John Rutherford regales British society with tales of his capture, twelve years earlier, by the Maoris of New Zealand. He tells of being held prisoner and forcibly tattooed by the North Islanders. Later his story proves to be false. Rutherford had willingly jumped ship and taken up with the Maoris because he was in love with a Maori woman. He apparently got the tattoos in order to become a full member of the tribe.

1841 AD

Phineas T. Barnum opens the Barnum American Museum, full of side show attractions, in New York City. It features James O'Connel, the first tattooed person to be exhibited in the U.S.

Phineas T. Barnum

1691 AD

A heavily tattooed slave from the Philippines, Jeoly, is brought to London and put on display as "The Painted Prince, Giolo," reintroducing Western culture to tattoos. He soon dies of small-pox. The Painted Prince is most remembered as the first tattooed "attraction"—a person who displayed their body art for money. Of course, as in the case of Jeoly, the person did not always have the right to say whether they wished to be displayed, and they probably didn't see any of the money either.

1771 AD

Joseph Banks, who sailed with Captain James Cook on his first voyage to explore the South Pacific, returns to England with a written account of Polynesian tattooing and—a tattoo!

1862 AD

Like many Christian pilgrims before and after him, King Edward VII (then the Prince of Wales), gets a permanent memento of his trip to the Holy Land in the form of a Jerusalem Cross tattooed on his arm. It is a habit that will continue throughout his life, as he collects tattoo mementos from all over the world. His love of tattoos sparks a craze among other British aristo-cratic men and naval officers.

1870 AD

Martin Hildebrandt, who tattooed soldiers from both sides on the front lines during the Civil War, opens the first tattoo parlor in the U.S., in New York City. Hildebrandt's wife, Nora, who was a sideshow attraction with Barnum & Bailey, was said to have 365 tattoos.

1879 AD

For identification purposes, England begins to tattoo criminals. The brief resurgence of popularity that tattoos experienced in Western society dies out, as tattoos become associated with convicts and outlaws.

1891 AD

Samuel O'Reilly, a competitor of Hildebrandt's in New York, patents the first electric tattooing machine, based on Thomas Edison's design for an engraving machine.

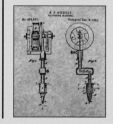

1974 AD

Tattooist Lyle Tuttle opens his tattoo museum in San Francisco.

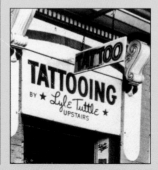

1976 AD

The First World Convention of Tattoo Artists & Fans is held January 24-25, 1976 in Houston, Texas. Twenty years later artists and fans would gather again to celebrate the historic occasion—this time with quite a few more people in attendance.

1927 AD

 British tattooist George Burchett begins tattooing the Great Omi, one of the most famous of all tattooed side-show performers. Burchett tattoos Omi's body entirely in zebra stripes. Omi then adds the finishing touches, filing his teeth to razor sharp points and inserting a tusk into his pierced septum.

1944 AD

The March 4th cover of the Saturday Evening Post features a Norman Rockwell painting of a tattooist inking a young sailor.

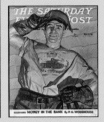

1981 AD

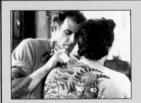

Dr. Samuel Zuckerman invents the long-lasting cosmetic temporary tattoo for use in the film Tattoo.

1981 AD

Tattooed lady Betty Broadbent is the first person to be inducted into the Tattoo Hall of Fame, established that year.

TATTOOED CELEBRITIES

Tattoos aren't just for rock stars and movie stars, you know. A lot of celebrities and even world leaders have had tattoos. Herewith a brief list:

Aaron Neville	Christy Turlington	Frank Banham
Aerosmith	Courtney Love	Gabrielle Reece
Allen Iverson	Czar Nicholas II	George Bush
Alyssa Milano	Damon Stoudamire	George Schultz
Andre Rison	Dana Sculley	Gin Blossoms
Angel Manfredy	Daryl Hall	Goo Goo Dolls
Angelina Jolie	David Wells	Greg Allman
Ani DiFranco	Dell Harris	H2O
Annie Sprinkle	Dennis Rodman	Henry Rollins
Barry Goldwater	DJ Keoki	Henry the IV
Bart Simpson (removed)	Drew Barrymore	Howard Stern
Bernie Taupin	Duke of Clarence	Indigo Girls
Bill Goldberg	Ellen Terry	James Brown
Billy Idol	Everlast	Janeane Garofolo
Biohazard	Fabulous Thunderbirds	Janet Jackson
Busta Rhymes	Faith Evans	Jean-Paul Gaultier
Catherine the Great	Faith Hill	Jennifer Tilley
Charlie Sheen	Flip Wilson	Jenny Churchill
Cher (removed)	Foxy Brown	Joan Baez

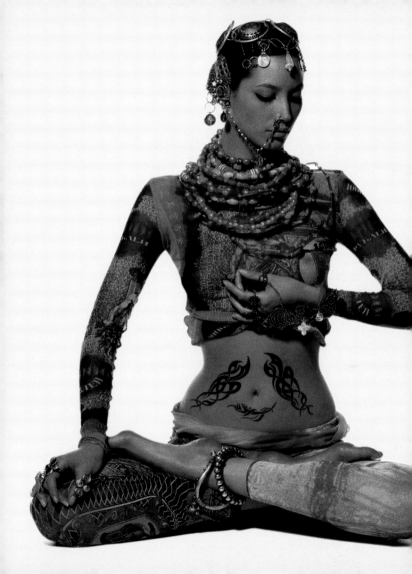

John Mellencamp	Mark Wallenberg	Rocky Mauia, The Rock
John Stamos	Melanie Griffith	Rose McGowan
Johnny Depp	Melvin Van Peebles	Roseanne
Johnny Winter	Michael Jordan	Scotty Pippen
Jon Bon Jovi	Mickey Rourke	Sean Penn
Judas Priest	Mike Tyson	Sean "Puff Daddy" Combs
Julia Roberts	Minnie Driver	Sean Connery
Keith Flynt	Motley Crüe	Shaquille O'Neal
King Alfonso of Spain	Naomi Campbell	Spice Girls' Mel (B) G
King Edward VII	Nicholas Cage	Stephanie Seymour
King Frederick IX of Denmark	Nicole Eggert	Stephen Marbury
King George V of England	Ozzy Osbourne	Stone Cold Steve Austin
Korn	Pamela Anderson	Susan Saint James
Lachlan Murdoch	Pearl Bailey	Third Eye Blind
LaToya Jackson	Peter Fonda	Tim Duncan
Lee Trevino	Peter the Great	Tim Roth
Lenny Kravitz	Ramones	TLC
LL Cool J	Randy Moss	Tom Arnold
Lorenzo Lamas	Red Hot Chili Peppers	Tony Danza
Luis "El Diablo" Rodriguez	Riddick Bowe	Undertaker
Madonna	Ringo Starr	Viveca A. Fox
Marcus Camby	Rob Zombie	Whoopi Goldberg
Marilyn Manson	Robert Mitchum	Wilhelm II

CAN YOU MATCH THE CELEBRITY WITH THE TATTOO?

1. Detective Dana Scully
2. Drew Barrymore
3. Mel (B) G/Spice Girls
4. Minnie Driver
5. Viveca A. Fox
6. Angelina Jolie
7. Tom Arnold
8. Julia Roberts
9. Alyssa Milano
10. Marcus Camby
11. Marilyn Manson
12. Mike Tyson
13. Janeane Garofolo
14. Shaquille O'Neal
15. Tony Danza

a. "Keep on Truckin'"
b. the word "think" on right forearm
c. Mao Tse-tung on one bicep, Arthur Ashe on the other
d. Star of David
e. Japanese word for "death"
f. a cross & rosary beads
g. a rose on the buttock
h. a snake eating its own tail
i. Superman logo on arm
j. a butterfly below the navel
k. Chinese symbol & a heart
l. a fox on the arm
m. tribal work on the forearm with an eyeball in the middle
n. a Japanese symbol meaning "Spirit/Heart/Mind"
o. two Chinese words, one meaning "to strive," the other meaning "clan/family"

ANSWERS: 1-h, 2-j, 3-n, 4-g, 5-l, 6-e, 7-d, 8-k, 9-f, 10-o, 11-m, 12-c, 13-b, 14-i, 15-a

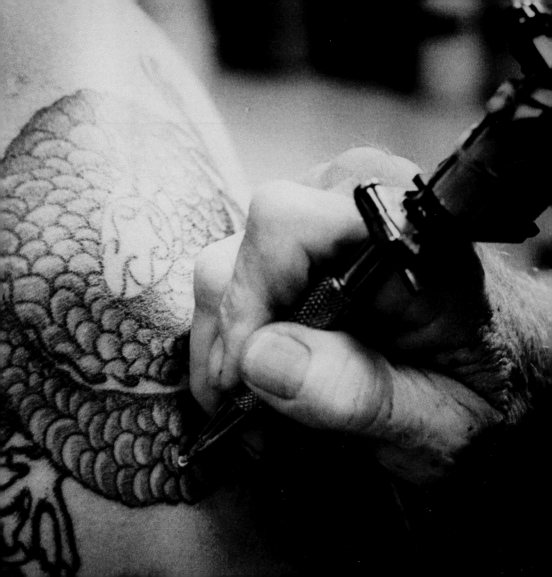

HOW · TATTOOING

W · O · R · K · S

PERMANENT TATTOOS

A TATTOO IS MADE BY PUSHING DIFFERENT COLORED pigments, often called "ink," under the skin with a needle or grouping of needles. The needle(s) puncture between the top and middle layers of your skin, filling all of the skin cells with ink. (When a tattoo is removed by laser surgery, the laser beam blasts the ink-filled skin cells apart, leaving the pigment to be naturally flushed away by your body.)

Your body heals the skin over the tattooed area, and since the top layer is opaque (kind of see-through, but tinged with your skin color) the tattoo pigment below it shows through. This is something to keep in mind

if you have a dark skin tone: whatever colors you choose for your tattoo will have to be seen through your skin's natural color.

The tattooist must accurately place the pigment at just the right depth. If the tattoo is too far into your skin, the lines will spread out and lose their sharpness because some of the ink will be washed away by the fluids in your body. On the other hand, if the pigment isn't placed far enough in your skin the tattoo will fade or fall out entirely because it will not have bonded properly with your skin.

TEMPTUS

A TEMPTU IS MADE OF TWO BASIC ELEMENTS: A DETAILED OUTLINE that is printed with a unique, safe, non-toxic cosmetic ink onto specially treated tissue paper, and non-toxic cosmetic body paint. The ink is released into the skin with an alcohol solution.

The design is then filled in with the FDA-approved body paint. You can blend colors together directly on the skin, and set the design with talcum powder. The tattoo will last up to a week or more, through swimming and bathing.

CHOOSING YOUR OWN TATTOO

THE FIRST STEP TO GETTING A TATTOO, PERMANENT OR TEMPORARY, is to know what you want, where you want it, and how big you want it to be. Too many people get inked on a whim, without really considering what they're about to have permanently etched onto their bodies. These are the same people who will be saving up for laser surgery or who end up wearing long-sleeves year round.

If you're going for permanent, it's very important that you pick a tattoo you'll still be proud to have on your body twenty, thirty, even forty years from now. And if you're thinking about getting a tattoo and having it removed later on—DON'T. Tattoo removal is far from 100% effective. Chemically burning off the tattoo or having it surgically cut out of your skin will leave you scarred. With the laser removal process, some colors are easier to eliminate than others, and some tattoos have been put so deeply into the skin it's almost impossible to get all of the ink out. Besides, it's a very expensive, painful, and long process. Following are some basic guidelines.

THINK BEFORE YOU INK : One of the joys of temporary tattoos is that they are, well, temporary. You can select a tattoo to wear for an hour, a day, a week— but you don't have to live with it forever. This works well for those of you who want to advertise the flavor-of-the-month teen idol or symbol without looking like a geek ten

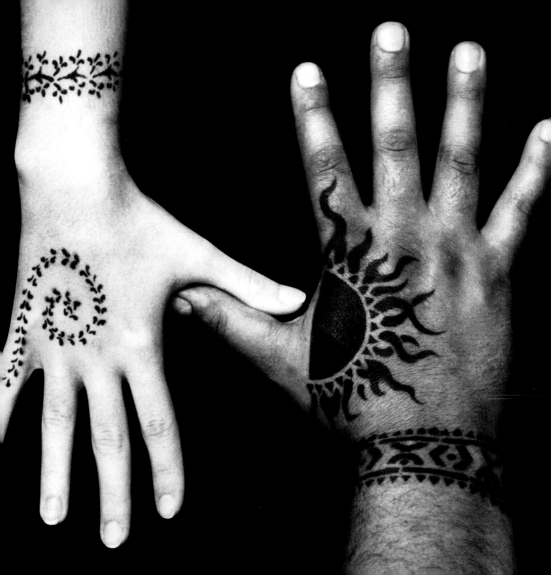

Pick the spot for your tattoo carefully— decide whether or not you want it to show. And don't forget that long sleeves are hot in the summer.

years down the road. Think of all those poor saps who have "I Love Milli Vanilli" tattoos on their behinds. If only they had been able to create temporary body art back then.

In choosing a permanent tattoo, try to stay away from images that are too trendy, like a band logo or a cartoon character; many of the things that seem cool to you now you may not even remember five years from today! Think of how you feel when you look at pictures of yourself from a few years ago—isn't that haircut ridiculous? Can you believe you actually went outside dressed like that? Well, your hair can grow out and you can always change your clothes, but that tattoo is FOREVER. Think before you ink.

PICK YOUR SPOT: Where do you want your tattoo? Many people get their first tattoos in discreet places that can be hidden by clothing, such as an upper arm, the back, the belly, or an ankle. There is still a lot of prejudice against multi-colored people; some businesses will either fire you or refuse to hire you if you have a tattoo, and since there are no discrimination laws to protect tattooed people, there isn't much you can do about it. That's why most tattooists have the "Head-Neck-Hands-Feet" rule, which signifies four places any conscientious tattooist won't touch—especially on a first-timer— because of the difficulty in covering those areas up.

SIZE DOES MATTER: Have you ever heard the story of the ferocious hamster? A roughneck goes into a tattoo parlor to get a tattoo that will represent his fierce nature. He picks out a snarling grizzly bear, a large tattoo that should cover his entire back, but decides to get it done much smaller. Even though the tattooist tries to convince him that this design needs to be done larger, the kid insists on getting it done really tiny on his arm. The result? The most ferocious-looking hamster tattoo you've ever seen. The moral of this story is SIZE DOES MATTER. Not every tattoo can be reduced to a smaller size without losing a lot of its impact. The rule of thumb is the more detail the design has, the bigger it needs to be. This is important to remember when considering your tattoo.

HOW TO FIND THE DESIGN OF YOUR DREAMS: People find the design of their dreams in many different ways. In the Gallery section of this book, you'll find a variety of different images to select from. But the most common way is by selecting a piece from a tattooist's library of pre-drawn tattoos called "flash." These are the many different designs you see all over the walls of most tattoo parlors. Often, the tattooist hasn't drawn these designs himself—they have been purchased from another artist.

The problem with selecting a piece of flash as your tattoo is that anyone else can also select that piece. Many tattooists will offer to make your flash tattoo unique by changing

something in the design so that no one else has exactly what you have. To make sure that nobody else will be walking around with your tattoo, you can get a "custom" piece, which means either you, your tattooist, or an outside artist (or any combination thereof) will design the piece specifically for you. Inspiration for your custom design can come from anywhere—a photo, a book, a comic, a painting, a package design, a dream you had once...just about anything can be translated into your skin!

A I N ' T R E A L A I N ' T B A D : Temptus allow you to "test drive" a tattoo, giving you a visual guide to figuring out the design, the placement, and the size for your work. You'd never buy a pair of shoes without first trying them on to see if they fit and how

they look on you, right? For the same reason, it's a great idea to play around with your temporary tattoo kit as long as you like before going for the real thing.

(above) Various examples of vintage temporary tattoos. When transferred onto the skin, they read correctly. (right) A sheet of vintage military flash.

mple, now decorate.

hold.

cheap and cheap work

s!

ce between tattooed peo-

oed people is that tattooed

if you're not tattooed.

6. Dream it tonight, drill it t

7. Born to adorn.

8. Think before you ink.

9. Tattooed people come in

10. Tattoos aren't for everybo
 good for most people!

11. If it didn't hurt, everybod
 have one.

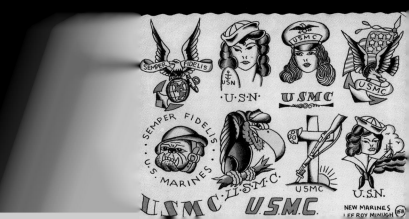

NEW MARINES
LEE ROY MINUGH (158)

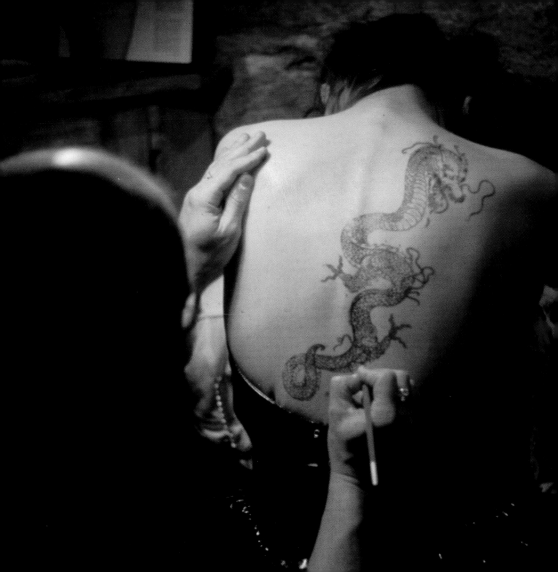

H·O·W · T·O · U·S·E · Y·O·U·R

TEMPTU·KIT

YOUR TEMPTU TEMPORARY TATTOO KIT WILL NOT ONLY give you the chance to play around with different designs, colors, and placements if you're considering the real thing, it's also an easy way to change your look for the moment. The transfers are great to wear out; they add a little something special to any outfit or occasion. The artists at Temptu have applied their work to models at fashion shows, musicians in concert, and other people who just want to shine a little brighter on a special night. These talented people have paved the way for making temporary body art a dazzling fashion accessory.

Temptus can also be lots of fun in groups. The kit is a great addition to any party; you can give your guests a special little something to remem-

ber the evening by. You can have a designated Temptuist applying temporary tats to anyone who wants them throughout the event or just leave the kit out for people to decorate themselves and others; it's a fun, easy, and unique activity that everyone will enjoy. From a child's birthday to an office get-together, Temptus add flair to a good time.

With the proper care, Temptu tattoos can last up to a week, even through showering and swimming, otherwise they can be removed instantly with a little rubbing alcohol or baby oil. The tattoos are completely safe, non-toxic, and contain only FDA approved ingredients.

W H A T Y O U R K I T I N C L U D E S

✳ 3 Vials of Paint—Red, Yellow, Blue ✳ 1 brush ✳ More than 30 tattoo transfers
WHAT YOU NEED: ✳ Rubbing Alcohol ✳ Cotton Balls ✳ Talcum (Baby) Powder ✳ Q-Tips

HERE'S HOW TO REACH OUT AND PAINT SOMEONE:

1. First, pick your design and any additional colors you want to add to it. Then, decide where you want your Temptu.

2. Wipe your skin lightly and evenly with ordinary rubbing alcohol (the alcohol will pull the design off of the paper and allow it to stay on your skin). Temptus work

best on parts of the body that are hairless and flat (as opposed to the movable joints on wrists, knees and elbows).

3. While the skin is still moist, carefully lay the transfer face down, pressing it lightly to help it adhere to your skin. Dab the transfer with rubbing alcohol until the design shows through. Repeat the process.

4. Lift the transfer off while it is still wet. Slowly peel the paper off your skin. Blow on the tattoo a little to make sure it is completely dry.

5. Sprinkle a little talcum powder over your Temptu to help it set.

6. If you want to paint in your Temptu, use one color at a time, and wipe the brush clean on a paper towel before using the next color. Shake the bottles well, and use two or more thin coats. Don't worry if

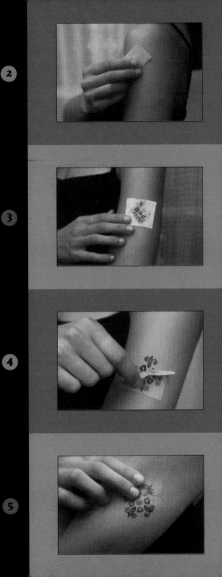

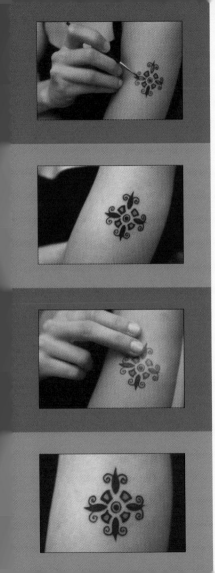

you make a mistake—a little rubbing alcohol on the end of a Q-tip will remove any errors. Paints can be blended right on the skin. In case you don't remember the combinations from your elementary school art class, here they are:

Yellow + Blue = Green

Blue + Red = Purple

Yellow + Red = Orange

All colors = Brown

7. Let the paint dry for at least one minute.

8. After you have completed painting in your tattoo, blow on it to make sure it's dry and then sprinkle a little powder on the area.

9. Presto! Now you're ready to impress your friends and freak out mom!

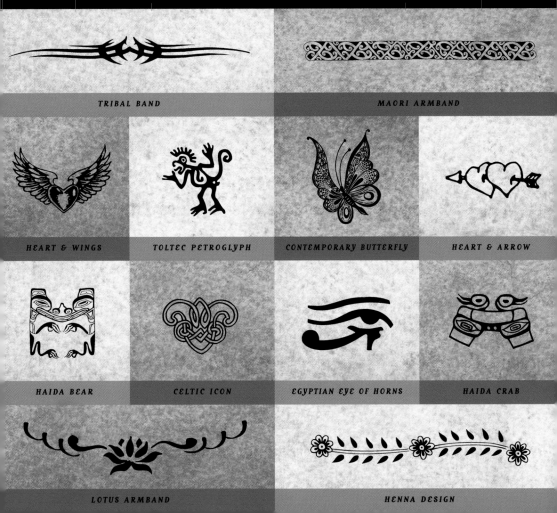

TRIBAL BAND

MAORI ARMBAND

HEART & WINGS

TOLTEC PETROGLYPH

CONTEMPORARY BUTTERFLY

HEART & ARROW

HAIDA BEAR

CELTIC ICON

EGYPTIAN EYE OF HORNS

HAIDA CRAB

LOTUS ARMBAND

HENNA DESIGN

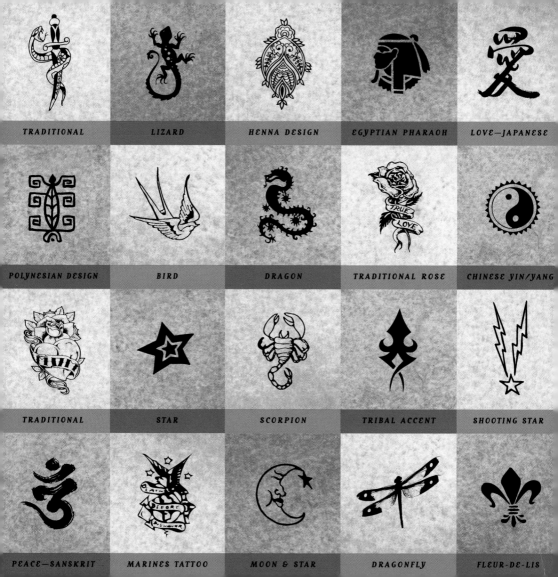

TRADITIONAL

LIZARD

HENNA DESIGN

EGYPTIAN PHARAOH

LOVE—JAPANESE

POLYNESIAN DESIGN

BIRD

DRAGON

TRADITIONAL ROSE

CHINESE YIN/YANG

TRADITIONAL

STAR

SCORPION

TRIBAL ACCENT

SHOOTING STAR

PEACE—SANSKRIT

MARINES TATTOO

MOON & STAR

DRAGONFLY

FLEUR-DE-LIS

HOW TO MAINTAIN YOUR TEMPTU

YOUR TEMPTU CAN LAST UP TO A WEEK OR MORE, EVEN WITH BATHING and swimming. To prolong it, overpaint the design every two days. Powder it regularly with talcum, and be careful when drying or rubbing the area. Avoid contact with oils and lotions.

HOW TO REMOVE YOUR TEMPTU

YOU CAN EASILY REMOVE YOUR TEMPTU BY TAKING A LITTLE BIT OF rubbing alcohol or baby oil, rubbing it on the Temptu, and wiping it off with a soft cloth or swab.

SOME WAYS TO ENJOY YOUR TEMPTU TEMPORARY TATTOO KIT

* A Night On The Town—Spice up your look with a Temptu or two; no one will know they're not real unless you tell them!
* Costuming—Whether you're dressing up for Halloween or starring in a play or movie, tattoos add to your character's believability.
* Birthdays—Kids love tattoos, and so do teens, adults, and seniors! Any age can enjoy this activity.

* Sleep Overs & Slumber Parties—Tattoos go well with music, gossip, and games.

* Office Get Togethers—A great way to loosen people up and start conversations; you can learn something about your co-workers by the Temptus they choose.

* A Day At The Beach Or Pool—Since everyone is showing more skin anyway, why not decorate it? Don't worry, once your Temptu has set you can still enjoy the water.

* Fairs & Charity Events—Offer a Temptu tattoo for a small donation. It's an unconventional way to raise money for your favorite cause.

FUN AND GAMES

GUESS WHERE MY TATTOO IS: Put the Temptu kit into another room. One by one, have each player go into the room alone and put a tattoo somewhere on their body where it is hidden from view. When everyone is tattooed, each player then writes down their guesses for the location of every other player's tattoo. The one with the most correct answers wins.

NAME THAT TATTOO: Blindfold a friend. Using the paint, write a word or someone's name on your friend's arm or neck. Have them guess each letter as you go. When they have guessed what you've written, it's their turn to paint. Do this until you've filled up their arm.

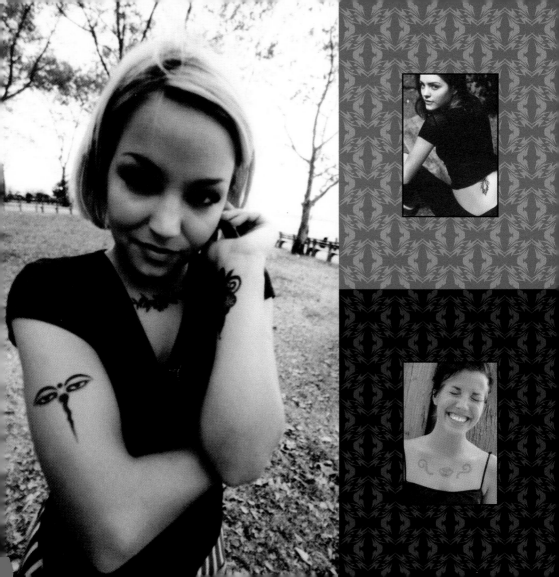

TATTOO TRIVIA

1. Archduke Ferdinand of Austria had a small tattoo of a snake which he believed would protect him from being shot. Unfortunately, he was assassinated by pistol in Sarajevo in 1914, triggering World War I.

2. Many tattooed people can testify to the protective power of skin art. If a tattooed person gets a minor skin breakout, bug bite, or other skin irritation, it's not unusual for them to experience a rash or swelling everywhere but where their tattoos are!

3. A tattoo apprenticeship usually lasts anywhere from two months to a year and costs anywhere from $2,500 to $ 10,000.

4. At the end of the 1800s, it was estimated that 90% of all American Navy men had tattoos.

5. A small dot tattooed on the right ring finger designates the tribe elder in gypsy clans.

6. James Brown had eyebrows tattooed on himself. He said he'd lost his eyebrows by getting repeatedly punched in the face as a young boxer and was, "...tired of painting them on every morning."

7. The very popular single needle, "black & gray" style tattooing (often used for doing portraits or very realistic tats), is also referred to as "joint style" or "jail house" because it originated in the prisons where would-be tattooists only had one needle and one color, black.

8. In *Night of the Hunter* Robert Mitchum plays an evil preacher with "LOVE" tattooed on one hand and "HATE" tattooed on the other.

9. Tattooing is often referred to as the "Ancient Art" because it has roots in humankind's earliest forms of expression.

10. Herve Villachez, who played Tatu on the original *Fantasy Island* TV show, was, in fact, tattooed.

11. Where does the word "tattoo" come from? Captain James Cook, the British navigator and explorer who charted and named many of the Pacific Islands, described the practice he saw in New Zealand and Tahiti as "tattaw." In many Polynesian languages, the word "ta-tatua" means "to strike properly." The English already had a word, "tattoo," which meant "a continuous, even drumming or rapping," so it seemed to fit.

12. In the third century, criminals who were sentenced to work in the mines were tattooed with a description of their crime, their punishment, and sometimes the name of the Roman emperor

they slaved under. Rather than becoming the stigma it was intended to be, if the slave survived the mines, his tattoos became a sign of his courage and strength.

13. In the early-to-mid 1800s sailors often mixed gunpowder into their tattoo ink, believing it would give them a longer life.

14. There is a rare side-effect experienced by a very few people who have the color red tattooed in their skin. It's called "red reaction" and has shown up anywhere from one to sixteen years after the tattoo was first done. The symptoms are swelling, inflammation, and itching where the skin has been inked with red pigment. Originally thought to be caused by the toxic ingredients used to make the color, even after the ingredients were changed there have still been reports of red reaction.

15. The Whei-chih, ancient inhabitants of Western Japan, who spent a lot of time in the water, tattooed their face and bodies in order to scare off dangerous sea creatures.

16. In twelfth century Japan, it was popular for two lovers to each get half of the same tattoo done, so that when they came together, the piece looked whole.

17. The native people of New Zealand, called Maori, used to cut off and preserve the tattooed heads of enemies who had been slain in battle. To possess one meant you had conquered a powerful foe. In the early 1800s, when European people began settling in New Zealand and trading with the Maoris, they took an interest in these heads. The Europeans would exchange firearms and ammunition for these prizes, which led to a shortage of preserved tattooed heads. Soon, any man with a tattooed head was in danger of being killed and having his head

chopped off! Often, unmarked slaves would be tattooed just to have their heads hacked off and sold to an eager European. The practice of "head trafficking" was finally outlawed in 1831.

18. French revolutionary Jean Baptiste Bernadotte is said to have had "Death To All Kings" tattooed on his arm. He later became the king of Sweden.

19. Per capita, New Zealand has more tattooed people than anywhere else in the world.

20. Responding in an on-line interview to a question regarding how fans express their love of his work, *The Simpsons* and *Futurama* creator Matt Groening wrote, "I think tattoos are the ultimate compliment for a cartoonist."

21. While dating Winona Ryder, Johnny Depp got a tattoo which read, "Winona Forever." After they broke up, he had it altered to read "Wino Forever." Similarly, when Pamela Anderson married Tommy Lee, they had each other's names tattooed on their ring fingers. When they broke up, Pamela had "Tommy" changed to "Mommy."

22. One of tattooist/artist Spider Webb's "conceptual tattoo performances" was called X-1000 and involved him tattooing an "x" on 999 people. On the thousandth person, he tattooed 1,000 tiny x's in the shape of a big X.

23. Approximately 12% of the U.S.'s population and 20 million others worldwide are tattooed.

24. Robert De Niro has 33 Temptu tattoos and one real tattoo as Max Cady in the 1991 version of *Cape Fear*—the panther is real.

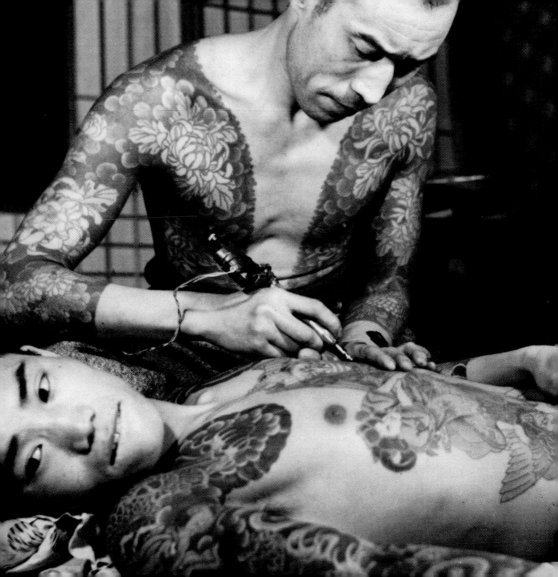

HOW·TO·FIND·THE·RIGHT
TATTOOIST

IF YOU'VE DECIDED TO MOVE BEYOND TEMPORARY tattoos to a permanent tattoo, you'll want to know who you can get to tattoo this living work of art. Don't just walk into the closest (or cheapest) tattoo parlor in town. The more research, effort, and thought you put into selecting the perfect tattooist for your piece, the happier you'll be with it.

There are plenty of tattoo magazines on the newsstands which give you tips, advice, and history, as well as featuring photos of tattoos by many different artists. You can also attend one of the many tattoo conventions that take place all over the world. At these events, tattoo fans and artists get together to show off their work and get new work done. The Internet

is also a good source of tattoo info and ideas. On a more local level, you can ask other tattooed people where they got theirs done. You can also visit all the tattoo parlors in your area to check their artists out.

YOU GET WHAT YOU PAY FOR

HOWEVER YOU GO ABOUT IT, THE MOST IMPORTANT THING IS THAT you go to a professional for your tattoo. A professional tattooist has been trained in three crucial areas: tattooing techniques, drawing, and disease prevention and sterilization. That means they have apprenticed or studied tattooing with a professional, practicing and learning tried and true methods of accomplishing the amazing things tattooists can do with skin. A good inkslinger should also be able to draw—this enables them to reproduce properly any design you bring to them and to create new designs themselves. Most importantly, they must understand how to prevent the spread of disease. They must sterilize all of their equipment in an autoclave and use disposable, one-use-only tools, like needles, ink caps, and latex gloves, at all times.

CLEANLINESS COUNTS

TATTOOISTS MUST FOLLOW A "STERILE CHAIN OF EVENTS," WHICH IS a strict set of rules that keeps everything safe from contamination—including you! Pros work in established tattoo studios, not out of their homes or vans. Their studios are extremely clean—doctor's office clean—and well lit. They have photos of other tattoos they have done available for you to look at in order to judge whether their work is suitable to your needs. The tattooists themselves should be clean (and sober).

And just because they're tattoo artists doesn't mean they should treat you like an idiot, either. Many people patronize tattooists who are mean and nasty and treat them badly for asking questions. A professional tattooist is happy to address all your concerns. They have nothing to hide—and they know that an educated customer is their best customer.

WHAT TO ASK YOUR TATTOOIST

How much is this going to cost?

Did you serve an apprenticeship? If so, with whom and how long?

How long have you been tattooing?

Where did you receive your training?

Could you spend some more time with me discussing the pros and cons of various designs?

Do you have a specialty—a style of tattooing that you're particularly good at?

How long have you been at this shop?

Is there an autoclave in your studio and is it checked regularly?

Have you had training in sterilization and prevention of disease transmission?

THE TATTOO NAME HALL OF FAME

Sailor Jerry	Crazy Philadelphia Eddie	Emma Porcupine
Doc Webb	Goodtime Charlie Cartwright	Spider Webb
Big Joe	Hanky Panky	Permanent Mark
Little Vinnie	Mel The Head	Painless Nell
Brooklyn Blackie	Debi The Illlustrator	Patty, Mistress of Pain
Coney Island Freddy	Famous Leg Greg	Rusty Needles
East Coast Al	Johnny Two Thumbs	Sting

W H A T T O E X P E C T

WHAT YOU REALLY WANT TO KNOW IS DOES IT HURT? WELL, OF course it hurts! A tattoo machine punctures your skin with a needle or grouping of needles about 3,000 times a minute; you're going to feel some degree of discomfort. Obviously it doesn't hurt that much, though, since so many, many people go through it. And honestly, it's not as if someone takes one long spike and stabs you again and again. The needle(s) which protrudes from the end of a tube on the tattoo machine makes quick, short punctures that are actually more annoying than painful. Some people feel that a little pain makes the whole process more meaningful, more like an ancient rite or ritual.

Since we all have different pain thresholds, it's difficult to say how it will feel. Ordinarily, getting tattooed over bones or tendons is more painful than getting tattooed over fleshier parts of the body. A few tattooists have experimented with topical anesthetics with varying degrees of success—there's even one tattooist who hypnotizes his clients to lessen their fear and discomfort—but as a rule, you just have to grin and bear it. You can take an over-the-counter pain reliever as long as it's not aspirin, ibuprofen, or any other "non-sterile anti-inflammatory drug." These common household medicines thin your blood, making it harder to clot, and the end result is you'll bleed heavier and longer while getting tattooed. Some people bleed a little, some hardly at all. Like the pain threshold, it's different for everyone.

WHAT TO WEAR

DRESS COMFORTABLY FOR YOUR APPOINTMENT, SINCE YOU'LL BE sitting in the same position for a while. Make sure that your clothing is loose wherever you're getting inked so as not to irritate your skin or the new piece when it's done. Also think about what clothing you're going to have to remove in order to get your new tattoo and prepare accordingly (clean underwear, a tank top under your shirt—you get the picture). And do everybody a favor, shower before you go. Finally, no respectable inkslinger will tattoo anyone under eighteen or anyone under the influence of drugs or alcohol.

HOW A TATTOO MACHINE WORKS

THERE ARE THREE MAIN PARTS TO A TATTOO MACHINE: THE FRAME, the electric mechanism which sits in the frame, and the tube, which holds the ink and needles. The needles are soldered onto a needle bar, which moves up and down inside the tube, coating the needles in ink and then pushing them into your skin. The needles penetrate between the first and second layers of skin, filling up the cells located there with ink. Tattoo "inks" are actually different colored pigments made from materials ranging from metal oxides to synthetic organic and acrylic-based dyes. None of these pigments are FDA approved, so if you have skin sensitivity, you should ask your tattooist to

perform a "patch test" using each of the colors you want in your tattoo in order to determine if you will have an allergic reaction.

HOW MUCH WILL IT COST?

PRICING VARIES GREATLY FROM ARTIST TO ARTIST, BUT THE OLD adage is true: you get what you pay for. Here's another old adage that's true: let the buyer beware! Never price shop for a tattoo. You're not shopping for a pair of shoes or some fruit—you're putting a permanent piece of artwork on your precious body.

You may find prices written under the flash on the wall, telling you specifically how much that particular piece in that size will cost. Or you may find out that the artist has a fixed hourly rate (anywhere from $50 to a few hundred dollars an hour). If you're going for a custom piece, the price may be a little higher and there will probably be a charge for the time it took the inkslinger to design your tattoo. It's perfectly okay to ask for an estimate on the time it will take and how much it will cost (just remember, it's an estimate).

Finally, provided you're happy with the job the artist did, tipping is customary. 10-15% of the price is the usual.

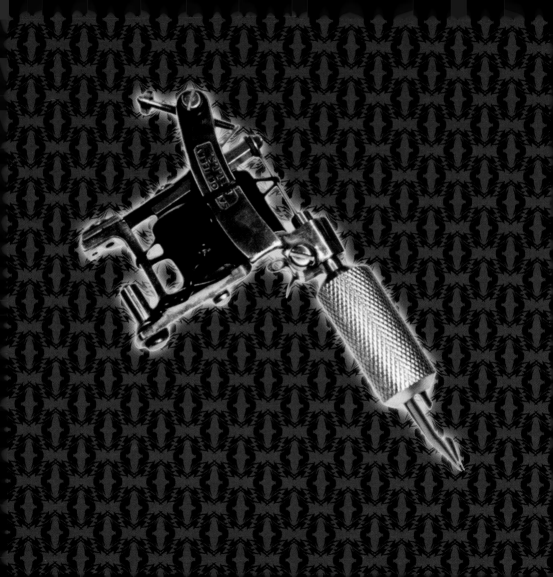

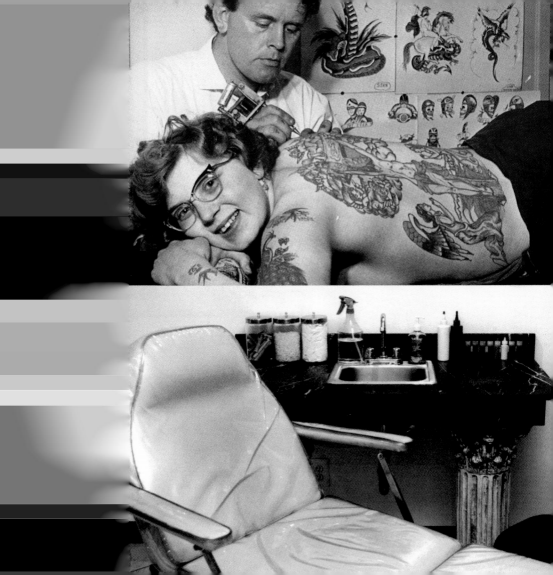

CARING FOR YOUR TATTOO

THE RECOMMENDED METHODS OF CARING FOR YOUR NEW TATTOO can vary greatly from artist to artist. Some tattooists wrap your new tattoo in plastic wrap, some in a sterile bandage. Some advise keeping your bandage on for two hours, some for twenty-four. Some insist the healing tattoo stay well-moisturized, some say moisture is a new tat's worst enemy. Some suggest you use antibiotic ointment on your tattoo, others Vitamin A & D ointment or common skin lotion. While it's probably best that you follow whatever your tattooist says to do, here are some guidelines for caring for your tattoo based on a number of different methods.

Once your tattoo is done, the tattooist will spray it with an alcohol-based solution and carefully wipe it clean. The tattooist will apply a liberal coating of a skin-soothing ointment and then cover your tattoo in a sterile dressing—if you are given the option of "paper or plastic" (sterile bandage or plastic wrap) choose the sterile bandage. It allows your new tattoo to breathe while still protecting it from airborne pathogens.

Keep the bandage on for a few hours and when you do remove it, peel it back slowly. The key to healing your new tattoo is not to pick the scabs or peeling skin and not to scratch when it itches—the scabs must fall off on their own with no help from you. It's perfectly normal for there to be some ink and blood on the bandage. Gently wash the area with a mild soap until all of the old ointment and gunk is gone; avoid having a strong

stream of water from the faucet hit the tattoo directly. Gently pat it dry with a clean towel. Apply a light layer of ointment. (What kind is up to you, although it makes sense to use something as chemical-free as possible—ask your tattooist.)

THE FIRST WEEK

THE FIRST WEEK OF HEALING YOUR TATTOO IS REALLY IMPORTANT. Remember, your skin is in a kind of shock, so you have to be as careful with the area as you possibly can. Keep the area clean and keep it lightly moisturized (you'll be able to feel when the area is drying up by a sensation of tightening and irritation). Keep it covered with loose clothing. Do not go in a pool, a jacuzzi, a sauna, or a steam room and try to avoid soaking the tattoo in the tub or putting it under a direct stream of water in the shower. Do not expose the tattoo to direct sunlight. And remember, NO PICKING OR SCRATCHING. It may be a few weeks before your tattoo is entirely healed. The most important thing is that it not get infected. If you follow the above precautions, infection shouldn't be a problem. If you do experience anything out of the ordinary, such as inflammation or redness around the edges, return to your tattooist immediately. He or she may recommend a mild over-the-counter antibiotic. If that doesn't help, go to a doctor.

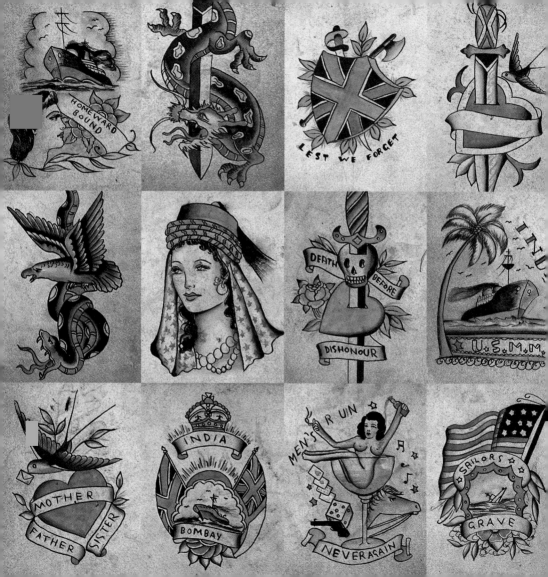

THE · TATTOO GALLERY

THERE ARE THOUSANDS OF DIFFERENT TATTOO DESIGNS that have been created over the years, and you can recreate almost all of them with the components of your kit—just use a little creativity, and a little paint. This section will discuss the different types of tattoos that are out there, and their origins and meanings. Think of it as a gallery for inspiration.

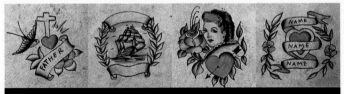

Tattoo parlors exhibit "flash" for customers to choose from.

THE CELTIC GALLERY

TODAY WE CONSIDER PEOPLE OF THE UNITED KINGDOM (ENGLAND, Scotland, Ireland and Wales) to be of Celtic descent, but at one time, before they were invaded by the Romans, the Celts spread from central and western Europe to the British Isles, and as far as Asia Minor. They were known as fierce warriors, men and women alike, who went into battle completely naked and "painted" (perhaps tattooed) blue and green, but they were also a spiritually and artistically rich race.

The Celtic style of tattooing is typified by flowing lines which are often interlaced, commonly called "knotwork." Far from being merely decorative, Celtic knotwork told stories, identified a person's clan affiliation, and even held hidden messages. Within the knotwork were words, symbols, representations of their gods and heroes, and likenesses of their sacred animals. The knotwork itself, which has no beginning and no end, represents the interconnection of everything on Earth and, since the Celts believed the human soul was indestructible, it was a symbol of eternal life as well.

Most Celtic knotwork is based on designs found in *The Book of Kells*, an ornately illustrated biblical text drawn by monks thirteen hundred years ago.

CELTIC ILLUMINATION

CELTIC SUN

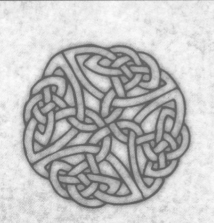

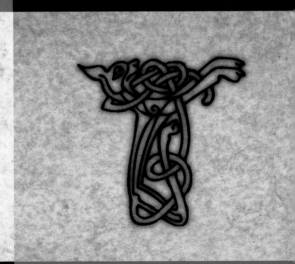

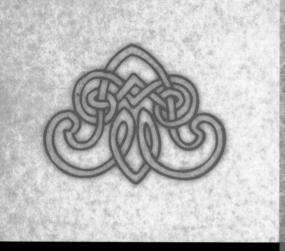

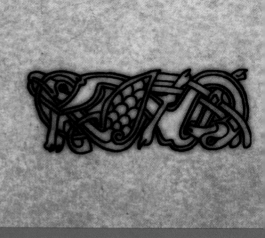

CELTIC ICON

CELTIC FISH

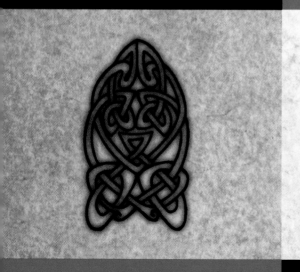

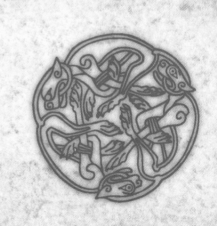

CELTIC ICON

CELTIC LION

THE TRADITIONAL TATTOO GALLERY

WHAT WE CALL "TRADITIONAL" TATTOOS ARE THE TRIED AND TRUE designs of modern Western culture—panthers, roses, skulls, pin-up girls, devils, hearts— images that were inked on your grandfather, your great-grandfather, and your great-great-grandfather (and possibly your great-grandmother if she traveled with the circus!).

These designs come to us from servicemen, primarily sailors, who wanted to be inked with images from the exotic locales they had visited (tigers, hula girls, palm trees), mementos of home (a pin-up girl, a red rose), religious imagery (a cross, an angel) or with a token of their service and patriotism (an anchor, a flag).

Just like any other tattoo culture, traditional Western tats each have their own meaning. A skull means you are not afraid of death, King Neptune tattooed on your leg means you have crossed the equator, a rose is representative of feminine beauty.

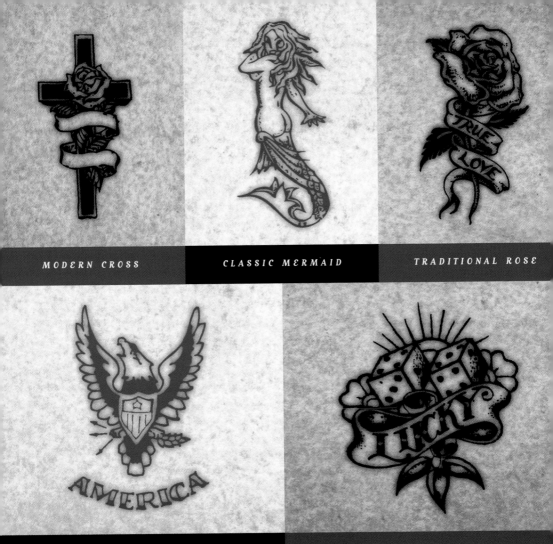

MODERN CROSS

CLASSIC MERMAID

TRADITIONAL ROSE

PATRIOTIC EAGLE

CLASSIC TATTOO

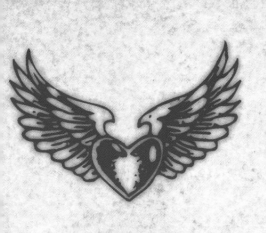
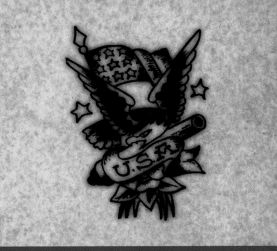

HEART AND WINGS

MILITARY

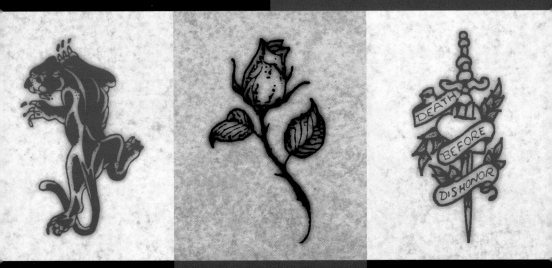

CLASSIC PANTHER

LONG STEM ROSE

TRADITIONAL MARINE TATTOO

THE DECORATIVE GALLERY

SOME DESIGNS ARE MEANT TO BE WORN ON SPECIFIC PARTS OF THE body. Any tattoo with a blank spot in the middle looks great around your navel or nipple. Bands are made to encompass your arms or legs. Circular tattoos should be placed on round parts of the body, like a bicep or calf, and long, rectangular pieces look best running down your arm, your leg or across the bottom or top of your back.

You can get creative and use several band tattoos to make a chain around your waist or use a combination of circular and rectangular to highlight your curves and planes.

CONTEMPORARY BUTTERFLY

MIDRIFF TATTOO

FLORAL WRIST/ANKLE DESIGN

STRING OF HEARTS

DELICATE TRIBAL STYLE

ART NOUVEAU ARMBAND

THE TRIBAL GALLERY

TODAY, MANY PEOPLE ARE INTERESTED IN THE TRIBAL STYLE OF tattooing, which uses design elements from many ancient traditions. Especially popular are motifs from Oceania, the islands of the south, west, and central parts of the Pacific Ocean, which includes Polynesia, Melanesia, Micronesia, and New Zealand.

The Oceanian styles are varied, but they do share certain characteristics. The designs break down into two main categories: they are abstract or so highly stylized they appear abstract at first, or they are intricate patterns made of lines and/or dots. Tribal tattoos are created to follow the contours of the wearer so the tattoo "fits" your body.

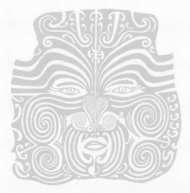

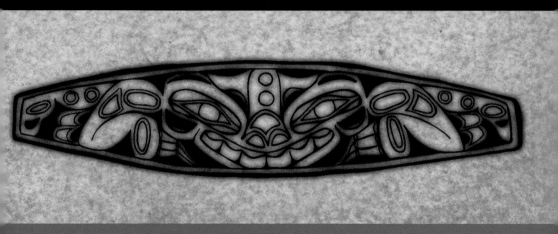

HAIDA SEA MONSTER DESIGN

HAIDA FIGURE

POLYNESIAN FACE

POLYNESIAN DESIGN

HAIDA FIGURE

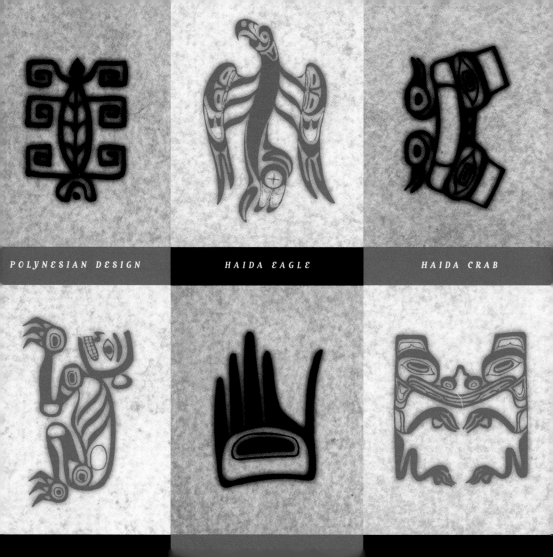

POLYNESIAN DESIGN

HAIDA EAGLE

HAIDA CRAB

THE ZODIAC GALLERY

Zodiac tattoos can incorporate the astrological symbol for the sign, the image representative of the sign, or even the personality characteristics of the sign.

ARIES : *March 21 through April 20*

Represented by the ram, Aries is a fire sign that is energetic, positive, impulsive, and enthusiastic. Aries' color is red and its ruler is Mars.

TAURUS : *April 21 through May 21*

Symbolized by the bull, this earth sign is stubborn but kind-hearted, persevering, methodical, and strong. The colors for Taurus are pink and blue, and the sign is ruled by Venus.

GEMINI : *May 22 through June 21*

Gemini is characterized by the twins. An air sign, Gemini is dualistic, restless, clever, and high-spirited. Yellow is the color for this sign, which is ruled by Mercury.

CANCER : *June 22 through July 22*

The crab or the moon are Cancer's symbols. A water sign, Cancers are persistent, sympathetic, sensitive, and easily influenced. Their color is violet and they are ruled by the Moon.

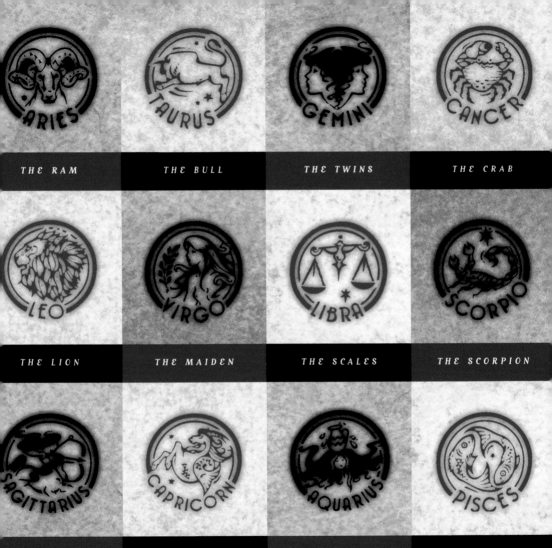

ARIES

THE RAM

TAURUS

THE BULL

GEMINI

THE TWINS

CANCER

THE CRAB

LEO

THE LION

VIRGO

THE MAIDEN

LIBRA

THE SCALES

SCORPIO

THE SCORPION

SAGITTARIUS

THE CENTAUR

CAPRICORN

THE GOAT

AQUARIUS

THE WATER BEARER

PISCES

THE TWO FISH

L E O : *July 23 through August 23*

Leo is the lion, of course. A fire sign which is proud, domineering, authoritative, and generous, their color is orange and they are ruled by the Sun.

V I R G O : *August 24 through September 23*

Depicted as a virgin or maiden, this is an earth sign. Virgos are intuitive, intelligent, industrious, and exact. Their colors are gray or navy blue and they are ruled by Mercury.

L I B R A : *September 24 through October 23*

Symbolized by a set of balance scales, this is an air sign. Well-balanced, just, impatient, and artistic, the representative color is indigo blue and the ruler is Venus.

S C O R P I O : *October 24 through November 22*

The scorpion characterizes this water sign. Scorpios are energetic, independent, passionate people with strong likes and dislikes. Their color is deep red and they are ruled by Mars.

S A G I T T A R I U S : *November 23 through December 21*

Depicted by the archer or a centaur drawing his bow, this fire sign is impulsive, restless, curious, and candid. Light blue is the Sagittarians' color and Jupiter is their ruler.

CAPRICORN: *December 22 through January 20*

Represented by the goat, Capricorn is an earth sign that is ambitious, melancholy, persevering, and restrained. This sign's color is green and its ruler is Saturn.

AQUARIUS: *January 21 through February 19*

The water-bearer or waves are their symbols. An air sign, Aquarians are honest, humane, thoughtful, and probing. Their color is electric blue and their ruler is Uranus.

PISCES: *February 20 through March 20*

Symbolized by two fish or two crescent moons, this is a water sign. Pisces are gentle, sensitive, kind, and pensive. Their color is sea-green and their ruler is Neptune.

THE CELESTIAL GALLERY

LOOK TO THE HEAVENS FOR POWERFUL TATTOO MOTIFS. THE SYMBOL meanings of the sun, moon, planets, and stars are plentiful, depending on what period of time, where, and whom we're talking about, but we can still gather some general meaning from these potent symbols.

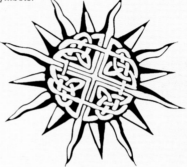

THE SUN : The sun is the male side of the masculine/feminine balance. The sun represents the "divine eye," the source of life and energy, a symbol of spiritual illumination, and the literal son of Heaven. The sun god, Helios, is depicted as driving his chariot across the sky from east to west daily and the act of the sun rising daily represents eternal life.

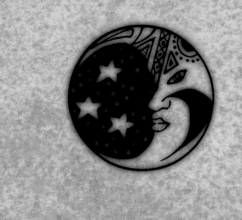

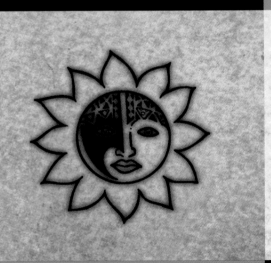

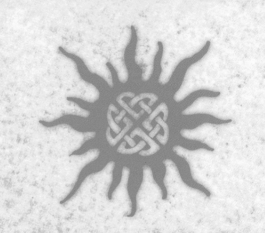

THE MOON: The moon is the female side of the masculine/feminine balance. As the opposite of light and divination, the moon stands for all that is mysterious, magical, and of the earth. The lunar cycle is symbolic of nature's cycles, whether it be the crop calendar of planting, growing, harvesting, and fallowing or the human life cycle of birth, adulthood, old age, and death.

THE STARS: In ancient times, stars were thought of as living things, whether they were mythic heroes, heavenly residents, or even the souls of the dead or unborn. The common representation of stars as having points, while not true, offers a variety of meanings. The six-pointed star, or hexagram, is commonly interpreted as the Star of David. It has an older meaning, that of sexual union between a man and a woman. The five-pointed star, or pentacle, is commonly associated with magic, witchcraft, paganism, and devil-worship. In ancient times, it meant "life" and "health" and derived from the pattern formed by the core of an apple which has been cut in half. The four-pointed star, also called a star cross, was often used on compasses to represent the major directions. Its older meaning is as a symbol used to evoke the powers of the four elements, which each resided at one of the four corners of the earth.

THE PLANETS: All of the planets but one are named for gods and goddesses, and because of that, they leave rich impression in our minds.

MERCURY: The Roman messenger for the gods. Mercury ruled commerce, travel, and thievery.

VENUS: The Roman goddess of love and beauty.

EARTH: An old word for, well, the ground.

MARS: The Roman god of war.

JUPITER: The Roman supreme and most powerful of the gods.

SATURN: In Roman mythology, Saturn is the god of agriculture.

URANUS: In Greek mythology, Uranus is the earliest supreme god, the god and personification of the sky itself.

NEPTUNE: The Roman god of the sea.

PLUTO: The Roman god of the underworld who ruled the dead.

THE CHINESE AND JAPANESE CHARACTER GALLERY

THESE VERY POPULAR TATTOO DESIGNS CAN REPRESENT AN IDEA IN a single elegant symbol. Many non-Chinese and Japanese people choose them because even though their tattoo may be visible, its meaning will remain private (except, of course, to someone who can read that language).

HAPPINESS-CHINESE

HOPE-JAPANESE

LOVE-JAPANESE

FOREVER-JAPANESE

PROSPERITY-CHINESE

BEAUTY-CHINESE

THE ANCIENT CULTURES GALLERY

THERE ARE SOME ANCIENT SYMBOLS THAT ARE JUST AS POWERFUL to modern society as they were to the people for whom they were originally intended, and these symbols are also popular tattoo designs. Egyptian hieroglyphics, for example, were originally a way to keep track of a king's possessions—but eventually, enough symbols were developed to communicate more fully. They conveyed the ideas, beliefs, and longings of the Egyptian people. Some of these more esoteric images, such as the ankh (the sign of life), and the lotus (birth and rebirth) are still common symbols today.

In many cases, the symbol itself remains intact, but its meaning changes with the times. Whatever culture the ancient symbol comes from—Egyptian, Aztec, Pagan, Mexican, Native American—the ancient meaning it conveys, and the modern meaning you see within it, can make it a powerful choice for a tattoo.

AZTEC FIREBIRD

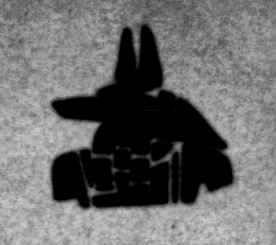

EGYPTIAN GOD OF THE DEAD

EGYPTIAN PHARAOH

CHINESE YIN/YANG

TOLTEC PETROGLYPH

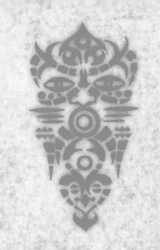

MODERN TRIBAL FANTASY MASK

TOLTEC BIRD

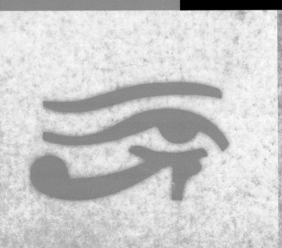

EGYPTIAN EYE OF HORUS

TOLTEC HEAD

THE FANTASY AND SCIENCE FICTION GALLERY

FANTASY AND SCIENCE FICTION MAKE PERFECT SUBJECT MATTER for skin art—the wilder the imagination, the wilder the tattoo image will be. In the worlds of Fantasy and Sci-Fi, we are free to dream and explore strange peoples, places, and things that are literally out of this world.

Fantasy tattoos include symbols such as wizards, dragons, unicorns, and fairies—the realms of magic, wonder, and adventure. Science fiction tattoos combine the potential of future technology with unbridled creativity and limitless imagination to depict other worlds and beings. Popular Sci-Fi tattoos include aliens, spaceships, and SCHWA symbols. Simply put, the world of Fantasy is the world of the ancient, the mysterious, and the arcane, while the world of Sci-Fi is the world of the future, with its limitless possibilities.

The only limit in both tattoo worlds is your own imagination.

SCHWA SYMBOL

THE GREEN MAN

DRAGON

ROCKET TRIP

THE REAPER　　　　　DRAGON　　　　　ALIEN DEVIL

DRAGON　　　　　ALIEN HOBO　　　　　THE REAPER

THE SOUTH ASIAN GALLERY

WHETHER USED ON THE BODY IN HENNA PATTERNS OR HIMALAYAN tattoos, or on ancient illuminated manuscripts and embroidered cloths, the basis for much of South Asian art lies in nature. The ripple of a wave, the wing of a bug, the pattern on a snake's back—anything on earth was and is used as stimulus for stunning complex designs and patterns.

Mendhi designs (henna designs from India) are usually taken from organic sources, such as the shapes of different leaves and flowers. There is no greater beauty than nature—it is the perfect source for inspiration.

Other popular South Asian symbols include depictions of the gods and goddesses of Hindu culture, Zen Buddhist symbols such as the Yin/Yang and the Buddha himself, and intricate designs symbolizing the chaotic order of the world.

TIBETAN DORJE SYMBOL

CHINESE BUDDHA

CHINESE BUDDHA

TIBETAN LOTUS SYMBOL

TIBETAN EYES — HENNA DESIGN

"PRAISE THE ALL POWERFUL"-SANSKRIT — HENNA DESIGN

HENNA DESIGN

HENNA DESIGN

HENNA DESIGN

HENNA DESIGN

OTHER TATTOOING STYLES

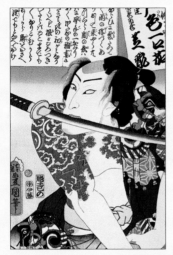

JAPANESE TATS: Even though the Japanese custom of tattooing, called *irezumi*, dates back to at least 5,000 BC, what we consider to be the traditional Japanese style has only been around since the mid-eighteenth century, when the art of woodblock illustrations was developed to illustrate Japanese books. By the beginning of the nineteenth century, the most popular novel of the time was *Suikoden*, translated from a Chinese story about a group of outlaws who were a lot like Robin Hood and his Merry Men. Many of the book's anti-heroes sported tattoos, which the woodblock artists lovingly recreated and, in turn, tattooists rendered into skin art. The characters and designs depicted in this book are still used in Japanese tattooing today.

Classic *irezumi* subjects are mythic and religious characters, dragons, dogs, fish, tigers, flowers, water, clouds, and lightning bolts.

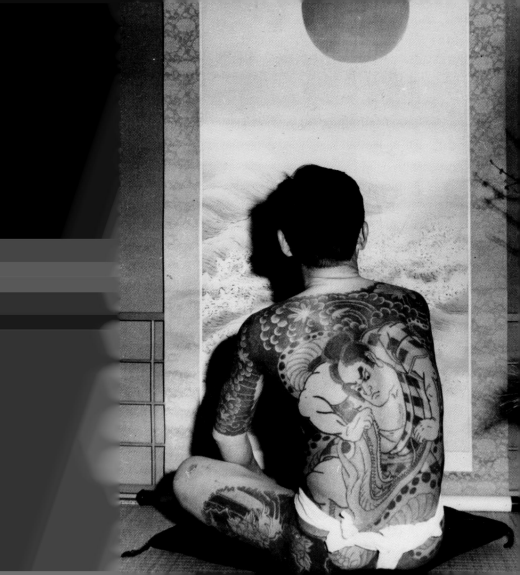

WILD STYLE TATS: Wild style tats incorporate art and ideas from the skateboard, graffiti, and hip-hop subcultures and harness all of the energy and spirit contained there. Words written in the free-flowing script of taggers and bombers are popular with a background of vivid "spray painted" colors. Skateboarders like to reproduce their deck designs on their skin and hip-hop kids ink the tools of their trade (two turntables and a microphone, anyone?).

SPORTS TATS: Sports tattoos break down into two main categories: a symbol of the sport itself or a symbol of a particular team. You can get a piece of ink that shows your fondness for tennis with a ball and racket, or your love of skateboarding with a design taken from your favorite deck. Or you could be really creative: how about a tattoo of Abner Doubleday to represent a passion for baseball?

Lots of people tattoo their favorite team's logo or their favorite player's jersey number on themselves as a show of support. Just be sure that before you get the team's insignia tattooed on your body you're going to be loyal no matter what. You might feel like celebrating your hometown heroes' winning season with some ink, but what happens if they go into a slump? You don't see that many Chicago Cubs tats—probably because the last time they won the World Series was in 1908! On the other hand, TLC's Lisa "Left Eye" Lopez had her favorite football player's number tattooed on her arm. Unfortunately, he was also her boyfriend, and when they

broke up she was so angry she tried to burn his house down. Strangely enough, she still has the tattoo.

POP CULTURE TATS: The release of *Star Wars: The Phantom Menace* prompted an outbreak of people scrambling to get one of the new characters tattooed on their bodies, even before the movie was released! Among these fans, it was more important to be the first on the block with a Phantom Menace tat than it was to make sure that they liked the character or even the movie. (Too bad for all of those eager beavers who got Jar-Jar Binks inked on them before they saw just how annoying he was!) Regardless, lots of *Star Wars* fans find their skin the perfect place to show their devotion to the series and there are lots of Yoda, Darth Vader, Darth Maul, and Boba Fett tattoos out there.

Disney characters are popular tattoo themes; some people collect these characters as tattoos on their bodies the way others collect them as figurines on their shelves. Unfortunately, Mickey and Company do not find this kind of devotion flattering; one man even got a letter from the Disney Corporation telling him the reproduction of their characters on his skin was illegal and he should cease and desist. You can't help but wonder how the people at Disney planned to stop him!

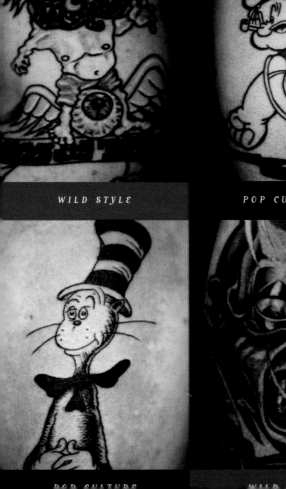

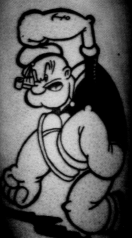

WILD STYLE

POP CULTURE

WILD STYLE

POP CULTURE

WILD STYLE

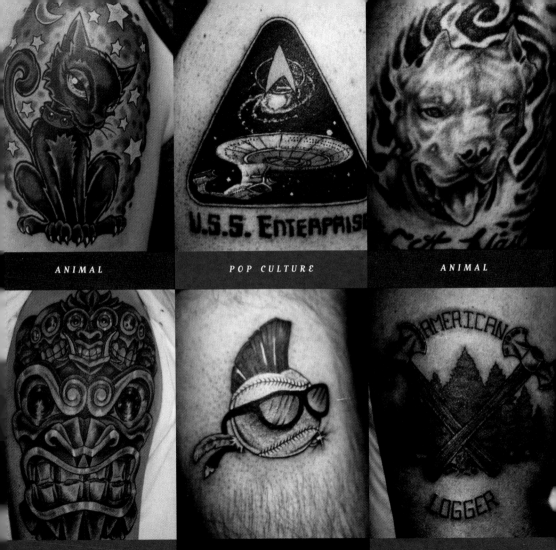

ANIMAL

POP CULTURE

ANIMAL

WILD STYLE

SPORTS

TRADE

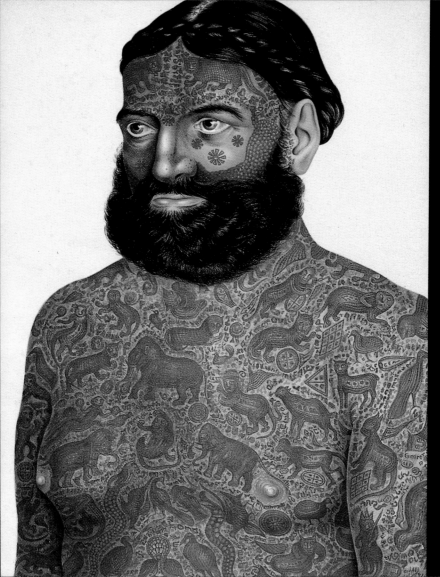

(left) Animals have always been a popular subject for tattoos, as shown in this illustration of a South Seas man.

(right) Masterpieces you can wear—examples of modern art tats.

ANIMAL TATS: If you're an animal lover, it's not unusual to get a portrait of your beloved pet(s) tattooed on you. It's a great way to show your devotion to that special friend who will never let you down. It's also much safer than getting a person's name or image (like your boyfriend or girlfriend) tattooed on your body. Many people relate to a particular animal, much like a Native American totem or guide, and they get one or several tattoos of their favorite creature. A few imaginative folks take it a step further, they have leopard spots, tiger stripes or eagle wings inked on themselves.

ART TATS: Some people use skin art to reproduce fine art. Your favorite painting, sculpture, or illustration can be imitated perfectly by a good tattooist. There are stunning recreations of everything from Da Vinci's "Mona Lisa" to the ancient cave paintings at Lascaux rendered in tattoo pigment.

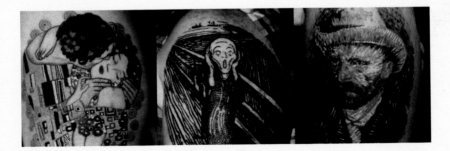

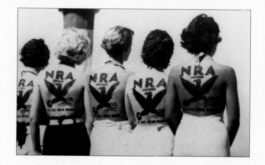

TRADE TATS: The tradition of tattooing an emblem of your profession on your body dates back for centuries. For hundreds of years Japanese firefighters used water-themed tattoos to distinguish their trade. These days, you'll find people from all walks of life with ink that signifies their job. Lots of medical workers choose the recognizable symbol of a snake wrapped around a cross and union members like carpenters and plumbers often get the tools of their trade inked on their skin. Plenty of police officers get their badge numbers permanently placed on their chests and there are even a few cashiers with UPC scan codes on their bodies!

Whether you are a coffee drinker, pipe fitter, bird watcher, pole vaulter, data processor, prize fighter, tree hugger or graffiti writer—a piece of permanent art that expresses your interests or profession is a great way to show the world what you're all about!

TATTOOS ON FILM

(Temptus used in those marked with an asterisk)

12 Monkeys
(1995) Bruce Willis, Brad Pitt
Bruce Willis' tattoo is used to ID him in the future, where he is a prisoner.

Blade
(1998) Wesley Snipes, Jared Harris
Tattooed half-vampire/half-human battles tattooed vampires.

The Blues Brothers
(1980) John Belushi, Dan Aykroyd
Jake & Elwood have their names tattooed on their knuckles.

Bound
(1996) Jennifer Tilley, Gina Gershon
Femme Violet and butch Corky are fatally attracted to each other—maybe it's their tattoos.

Cape Fear
(1991) Robert De Niro, Nick Nolte
Heavily tattooed Max Cady stalks a lawyer and his family.

Dead Man Walking
(1995) Sean Penn, Susan Sarandon
Death row inmate Matthew Poncelet sports jail house tats.

Escape From New York
(1981) Kurt Russell
Snake Plisskin has a tattoo of, you guessed it, a snake.

Foxfire
(1996) Angelina Jolie, Jenny Shimizu
A group of girlfriends all get the same tattoo to cement their friendship.

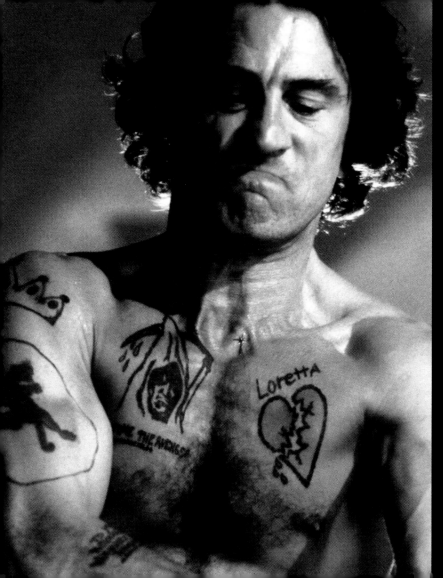

(left) Robert De Niro covered in Biblical and menacing Temptu tattoos as Max Cady in the movie **Cape Fear.**

(right) Bruce Dern plays a tattoo artist in the 1981 film **Tattoo,** for which the Temptu Temporary Tattoo process was invented by Dr. Samuel Zuckerman and makeup artists Fred Blau and Mike Hancock.

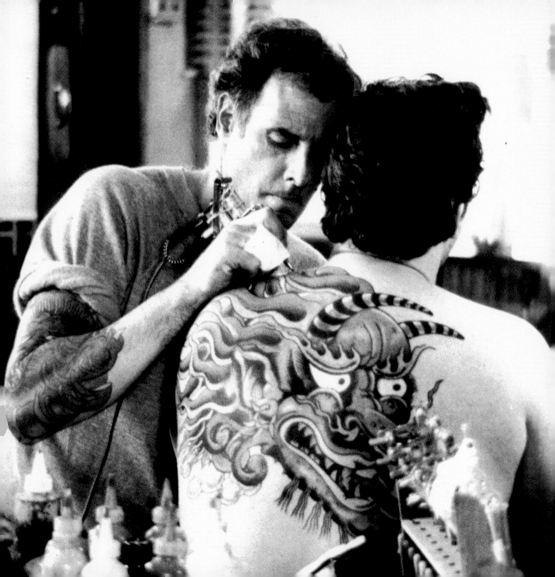

The Illustrated Man
(1969) Rod Stieger, Claire Bloom
Movie version of Ray Bradbury's novel about
a man whose tattoos each tell a story.

Lethal Weapon
(1987) Mel Gibson, Danny Glover
A little boy is able to ID a bad guy because he
has the same Special Forces tattoo as Riggs.

Night of the Hunter
(1955) Robert Mitchum, Shelley Winters
Psychotic, tattooed preacher murders his
bride and then hunts down his two step-
children in search of hidden loot.

*Once Were Warriors
(1994) Rena Owen, Temuera Morrison
The brutal existence of an urban Maori
family.

The Phoenix
(1992) Jamie Summers, E.Z. Rider
A tattooist searches for a worthy canvas.

The Piano
(1993) Holly Hunter, Harvey Kietel
Scottish woman and her daughter move
to nineteenth century New Zealand
and encounter an Englishman who has
"gone native."

Poison Ivy
(1992) Drew Barrymore, Sara Gilbert
The girls get tattooed.

Raising Arizona
(1987) Nicholas Cage, Holly Hunter
Nicolas Cage and the bounty hunter both
have the same Woody Woodpecker tattoo.

Rapa Nui
(1994) Jason Scott Lee, Esai Morales
The lost culture of ancient Easter Island is
recreated, complete with tattoos.

The Rapture
(1991) Mimi Rogers, David Duchovny
A spiritually bereft woman sees signs all
around her that the apocalypse is coming,
including a tattoo of a giant pearl on a
woman's back.

The Rocky Horror Picture Show

1975) Tim Curry, Susan Sarandon Dr. Frank N. Furter has a tattoo and asks Brad if he has any.

Romper Stomper

1993) Russell Crowe
Australian skinheads practice racism, get tattooed.

The Rose Tattoo

(1955) Burt Lancaster, Anna Magnani
An Italian-born widow meets a man who has the same rose tattoo as her late husband.

*The Runaway Bride

(1999) Julia Roberts, Richard Gere
Together again, but this time Julia sports a lovely rose Temptu on her shoulder.

Sonny Boy

(1990) David Carradine, Brad Dourif
Carradine plays a tattooed cross-dresser.

South Pacific

(1958) Mitzi Gaynor, Ray Walston
Walston's character has a ship tattooed on his chest.

The Tattooed Stranger

(1950) John Miles, Patricia Barry
A New York police detective investigates a murder that's only clue is the tattoo on the victim's wrist.

*Tattoo

(1981) Bruce Dern, Maude Adams
An obsessive tattooist kidnaps a model he had done body paint on and tattoos her entire body. "Temptus" were born for use in this flick.

Tattoo Boy

(1996) C. J. Barkus, Amanda Tirey
A child pornographer tattoos a fourteen year old boy in order to "brand" him.

Teresa's Tattoo

(1994) Adrianne Shelly, C. Thomas Howell
Teresa is kidnapped, drugged and made to look like another woman, Gloria, who had a dragon tattooed on her chest.

Waterworld

(1994) Kevin Costner, Dennis Hopper
A little girl's back is tattooed with a map to the only dry land left on the planet.

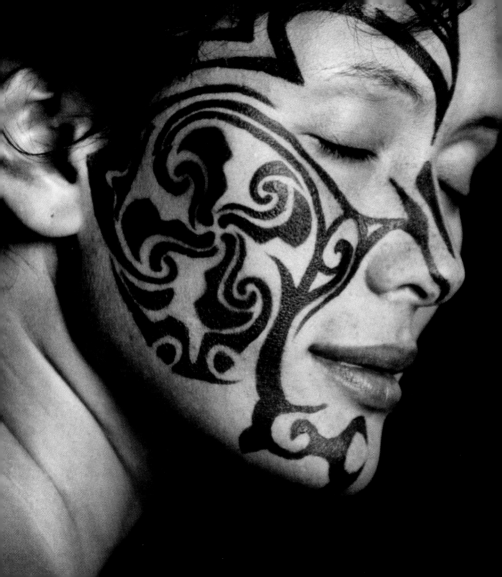

WHAT·ELSE, WHAT·NEXT?

THERE ARE MANY NEW AND INTERESTING KINDS OF body art. Some are as old as humankind itself and others are as contemporary as the technology which allowed them to come into existence. One thing's for sure, as long as people have the desire to use their bodies as living canvases, there will be a variety of ways to do so.

GLITTER PAINTING: A popular type of body painting can be found in the many glitter powders on the market. Sprinkle a little on your shoulders or cheek bones and it gives your skin a slight sparkle, a nice accent to your body's bone and muscle structure. It's like being touched with fairy dust. Stick-on jewels, called bindis, can be applied

anywhere for a dazzling effect. These trinkets come in a variety of shapes and colors and have a non-allergenic adhesive backing. Bindis were popularized by No Doubt's Gwen Stefani, who is often seen with one stuck on her forehead like a Hindu third eye (among other places).

M E N D H I : Mendhi is a traditional body art form which spread from the ancient Middle East to India, where it is still common. A paste is made from henna leaves and other organic substances and then applied to the hands and/or feet. It takes hours for the paste to dry, during which time the henna sinks into the skin. After the paste has dried, it's washed off and the dyed skin retains the pattern that was formed by the henna. Now henna dye is used all over the body, not just on hands and feet, and any kind of design can be made with it. Manufacturers are creating dyes in different colors, as well as making the drying time shorter. Mendhi has become a popular form of adornment today, with everyone from Madonna to Xena, Warrior Princess sporting intricate designs. Of course, taking someone else's traditions, like mendhi or bindis, and using them without understanding them (as both Madonna and the creators of Xena were accused of) can be very offensive to the people who consider the traditions more than mere decoration.

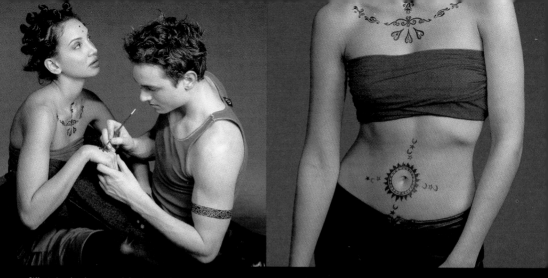

What is the future of body art? No one really knows, but today it includes mendhi, bindi, glitter paint, and anything else you can dream up. Your body is your canvas.

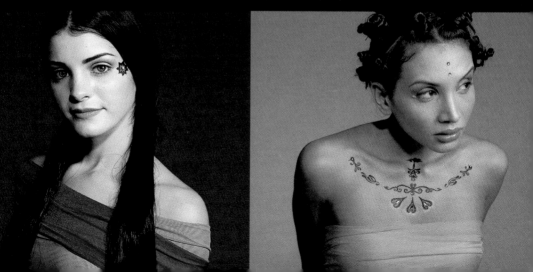

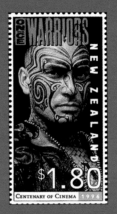

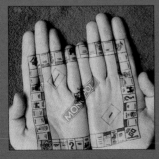

Temptus can be seen on bodies everywhere, but they're also found in print, as seen in this collection of images: (clockwise from left to right) Guinness beer ad, **Once Were Warriors** stamp, *Absolut ad,* **New York Times Magazine** *cover,* and Monopoly ad.

ABSOLUT RESTRAINT.

P I E R C I N G : Everyone is familiar with pierced ears, eyebrows, noses, and navels; body piercing is as popular as the tattoo trend. What you may not be familiar with are the more experimental styles being explored today. Over time, holes in your ear lobes can be stretched to larger and larger circumferences, so that it's easy to see through them. These holes can then be filled with hollow eyelets, known as "flesh tunnels," or with solid pieces, made of everything from wood to acrylic, called "plugs." A piece of body jewelry can also be threaded through several holes in the skin to create a weaving effect, or many pieces of jewelry can be formed into a complex design. A surface-to-surface piercing, rather than going all the way through a protruding body part (like your nose or your ear), lays flat against the skin, like a straight pin; all you see are the ends of the body jewelry. Most surface-to-surface piercings are only left in temporarily because they run a great risk of ripping out or being rejected by the body, but while they're in place they can be used to great dramatic effect. Some extreme examples are metal rings running in two columns down the wearer's back which are then laced, giving the illusion of a "skin corset," or a series of straight barbell piercings which encircle an arm, like a bracelet that's worn inside your skin instead of outside.

I M P L A N T S : Implants are another extreme form of body art. Not the kind you see on Hollywood starlets, these implants refer to materials (usually surgical stainless steel) which are "pocketed" under the first layer of skin so that you can see their shape

from the outside. Imagine putting an object in the pocket of your jeans; although you don't see the object, you can see its shape. The same effect is achieved by placing something under the skin. Would you like a row of metal spikes sticking out of your head like a mohawk? How about a series of bumps up your arm that give you the look of an amphibian alien? These things are possible with surgical implants. More radically, current medical attempts to graft organic materials, like coral, onto bones in order to regenerate their growth, could be used in wildly creative ways, like cultivating the growth of real horns, tails, or talons on a daring few.

3-D TATTOOS: There are a few pioneering artists who are experimenting with new and amazing possibilities in tattooing as well. Several people already sport 3-D tattoos—these pieces look completely normal, but when viewed with 3-D glasses, they virtually jump off the skin. Day glow, metallic, and invisible inks have also been attempted—with varying levels of success. Some innovative tattooists are working with chemists to perfect these innovative inks. How about "mood tattoos" made with tattoo pigments that change color as your body heats up? What about tattoos coupled with a microchip so that there was sound or light in your piece? As far-fetched as these things seem, the future holds many exciting possibilities in the world of body art.

You've got to have the knowledge, you've got to know how to use the ink.

- BROOKLYN BLACKIE

THE PRACTICE OF
SKIN
ORNAMENTATION
IS CERTAINLY AS WIDESPREAD
AND AS ANCIENT
AS MAN
HIMSELF.

-CHRISTOPHER GOTCH

Sec 146.012.
Tattoos Prohibited for Certain Persons.

(a) A TATTOOIST MAY NOT TATTOO:

(1) a person younger than 18 years of age without written and notarized consent from a parent or guardian who determines it to be in the best interest to cover a tattoo which contains:

> **(A)** obscene or offensive language or symbols;
>
> **(B)** gang-related names, symbols, or markings;
>
> **(C)** drug-related names, symbols, or markings;
>
> **(D)** some other type of words, symbols, or markings that the court considers would be in the best interest of the minor to cover; or

(2) a person whom the tattooist suspects is under the influence of alcohol or drugs.

— State Of Texas

FRIENDS DON'T LET FRIENDS GET

BAD INK

-DRAGON'S GLEN TATTOOING

I fully believe that tattoos are already in the skin. There comes a time when they must be made visible.

- LINDALEE

My tattoos make me what I am—I'm never really naked, and that's how I choose to be.

- IRENA THILL, TATTOOIST

WE ARE THE ONLY CREATURE ON THIS PLANET WHICH CHOOSES AND MANIPULATES ITS OWN APPEARANCE.

- TED POLHEMUS

GLOSSARY

* ***bindi*** (n) - a stick-on jewel from India.

* ***cockamamie*** (n) - early temporary tattoos made with water-soluble food dyes. Also called Lick and Stick.

* ***flash*** (n) - tattoo graphics that tattooists display on the walls of their parlors for customers to use as inspiration.

* ***ink*** (n) - slang for tattooing pigments; also (v) - slang for "to tattoo."

* ***inkslinger*** (n) - slang for a tattooist.

* ***implant*** (n) - material (usually surgical stainless steel) pocketed under the first layer of skin so as to be visible from the exterior.

* ***irezumi*** (n) - traditional Japanese style of tattooing, inspired by woodblock prints.

* ***memento mori*** (n) - from the Latin phrase meaning "remember that you must die," a reminder of our mortality.

* ***mendhi*** (n) - temporary body art style from India, done in henna.

* ***patch test*** (n) - test tattooist performs to check for allergic reaction to the pigments.

* ***tat*** (n) - slang for tattoo.

H O W T O G E T M O R E S T U F F

You have more than enough paints in your kit to use all the transfers provided—in fact, you've got a lot more—enough to do roughly 100 transfers. So what do you do with the rest of the stuff?

Get more transfers, of course! You can order a vast array of additional transfer designs directly from Temptu, in a variety of shapes, sizes, and themes. You can also order additional paints and henna!

Visit their website, www.temptu.com, for a complete listing of products, or call them directly at (212) 675-4000 to request a catalog.

EXCLUSIVE MAIL-IN OFFER! MAKE YOUR OWN TRANSFERS!

Since the title of the book is *Make Your Own Temporary Tattoo*, we thought we'd offer you the opportunity to actually make your own temporary tattoos. Funny how that works.

Throughout the book, we've told you not to rush into getting a tattoo—to think before you ink. To try before you buy. Well, now you can design your own Temptu transfers and test them out before you commit to the real thing—and for just a fraction of the cost of a permanent tattoo.

The body art wizards at Temptu will make your own artwork into Temptu transfers. Just send in your own artwork on disk, via e-mail, or via snail mail, and Temptu will print 25 transfers for only $10!

Visit their website, www.temptu.com, for information on how to order customized designs, or call them directly at (212) 675-4000 for information on how to order.

PHOTO CREDITS

Page 10: Photo by Stephanie Bruger; Body art by Julie Frappier and Gaetan Pelteir/Temporel; Courtesy of Temptu Marketing, Inc.

Page 12: Courtesy of Corbis/Bettman.

Page 18: Body art by Patrick Howe and Ann Shin; As seen in *Harper's Bazaar*.

Page 19: Body art by Temptu; As seen in French *Vogue*.

Page 20: Courtesy of *International Tattoo Arts Magazine*.

Page 23: Hands Tattoo—Tattoo by Jo Jo; Man's Back Tattoo—Courtesy of *International Tattoo Arts Magazine*; Jesus Christ Tattoo—Tattoo by Deano Cook.

Page 26: Body art and photo by Andre Revel; Courtesy of Studio Encre de Chine.

Page 28: Two Tattooed Northwest Indians—Courtesy of *International Tattoo Arts Magazine*; Tattooed Polynesian Man with Feather—Courtesy of Debbie Ullman; Tattooed Woman—Courtesy of *International Tattoo Arts Magazine*; Tattooed Older Polynesian Man—Courtesy of Debbie Ullman.

Page 29: Courtesy of Debbie Ullman.

Page 33: Top—Courtesy of *International Tattoo Arts Magazine*; Bottom—Courtesy of *Time* magazine.

Page 36: Courtesy of *International Tattoo Arts Magazine*.

Page 38: Top—Courtesy of *International Tattoo Arts Magazine*; Bottom—Courtesy of *International Tattoo Arts Magazine*.

Page 39: Top—Courtesy of *International Tattoo Arts Magazine*; Courtesy of *Saturday Evening Post*; Bottom—Courtesy of Universal Pictures.

Page 41: Body art by Temptu; As seen in *Vogue*.

Page 44: Courtesy of FPG.

Page 48: Body art by Temporel; Courtesy of Temporel.

Page 49: Body art by Temporel; Courtesy of Temporel.

Page 52: 1940s Temporary Tattoos—Courtesy of Debbie Ullman.

Page 53: Tattoo Flash by Lee Roy Minugh; Courtesy of Debbie Ullman.

Page 54: Photo by Beat Frutinger; Body art by Roy Zuckerman; Courtesy of Temptu Marketing, Inc.

Pages 56-57: Courtesy of Temptu Marketing, Inc.

Page 63: Courtesy of Temptu Marketing, Inc.

Page 66: Photo by Eric Radziejewski; Courtesy of Temptu Marketing, Inc.

Page 68: Courtesy of FPG.

Page 71: Courtesy of Studio Enigma.

Page 76: Courtesy of Technical Tattoo Supply.

Page 77: Top—Courtesy of *International Tattoo Arts Magazine*; Bottom—Courtesy of Studio Enigma.

Page 88-89: Butterfly and Woman illustrations by Ann Shin.

Page 102: Illustration by Ann Shin.

Page 114: Courtesy of *International Tattoo Arts Magazine*.

Page 115: Courtesy of FPG.

Page 116: Courtesy of Corbis/Bettman.

Page 120-121: Top Row—Tattoo by Denise de la Cerda; Tattoo by Tony Anguiano; Tattoo by Freak, Photo by Doug Mitchell; Tattoo by Dennis Halbritter; Tattoo by Stephanie Schmelter; Tattoo by Chris Cap, Photo by Dennis Feliciano; Bottom Row—Tattoo by Dan Allaston; Tattoo by Paco Excelo; Tattoo by Midwest Wade; Tattoo by Dave Fox; Tattoo by

Debbie Lenz; Tattoo by Mike Zelonis.

Page 122: Courtesy of Debbie Ullman.

Page 123: Tattoo by Inksmith & Rogers; Tattoo by Thane Sawyer; Tattoo by Robert Hernandez.

Page 124: Courtesy of Corbis/Bettman.

Page 126: Publicity photo from *Cape Fear*; Body art by Temptu; Courtesy of Universal Pictures.

Page 127: Publicity photo from *Tattoo*; Courtesy of Universal Pictures.

Page 130: Body art by Temporel; Courtesy of Temporel.

Page 133: Body art by Temptu; Courtesy of Temptu.

Page 134: Top Row—Guinness Beer Ad; Body art by Temptu; *Once Were Warriors* stamp; Body art by Temptu; Bottom Row—Monopoly Ad; Body art by Jane Choi; *New York Times Magazine* cover; Body art by Jane Choi.

Page 135: Photo by Steve Bronstein; Tattoo by Shotsie Gorman; Body art by Roy Zuckerman and Shotsie Gorman; Courtesy of Absolut Vodka.

ABOUT THE AUTHORS

ROY ZUCKERMAN is an accomplished body artist and writer, and is the founder of Temptu Marketing, Inc. He formed the company in 1980 to market the unique, non-toxic, long lasting cosmetic "temptus" his father invented. Roy's work has been seen in films, on Broadway, and in magazines around the world. He lives in New York, and this is his first book—but by no means his last.

JEAN-CHRIS MILLER is the editorial director of Art & Ink Enterprises, publishers of such magazines as *Skin Art*, *Tattoo Revue*, and several other alternative art magazines. She has written extensively on the subject of body art, consulted on tattoo-related film and television shows, and has published a book on the subject. She lives in New Jersey, and is currently at work on her first novel.